MANGA CHIBIS

HOW TO DRAW MANGA STEP BY STEP

This edition published in 2010 by
Search Press Ltd
Wellwood
North Farm Road
Tunbridge Wells
Kent TN2 3DR
www.searchpress.com

ISBN: 978-1-84448-599-4

This book was conceived, designed and produced by

maomao publications
Via Laietana, 32 4th fl. of. 104
08003 Barcelona, Spain
Tel.: [34] 93 481 57 22
Fax: [34] 93 317 42 08
mao@maomaopublications.com

Publisher: Paco Asensio
Editorial Coordination: Anja Llorella Oriol
Illustrations: Sergio Guinot Studio, www.artesecuencial.com
Texts: Sergio Guinot Studio, www.artesecuencial.com
English translation: Cillero & de Motta
Art Direction: Emma Termes Parera
Layout: Esperanza Escudero Pino
Cover design: Emma Termes Parera

Printed in Spain

MANGA CHIBIS

HOW TO DRAW MANGA STEP BY STEP

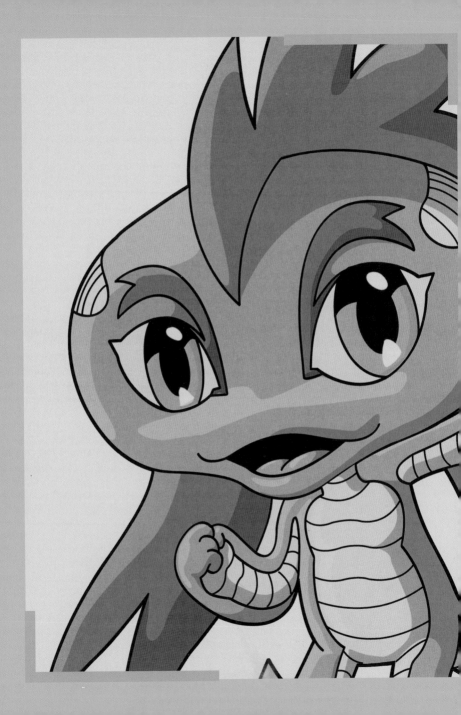

Table of Contents

007 Introduction
008 General Comments I: Outline and Sketching
General Comments II: Pencilling and Inking
009 General Comments III: Colour
General Comments IV: Lighting, Shading and Finishing Touches

011 The Eternal Battle between Good and Evil

012 Tarkano, Defender of Good
018 Sxlap, Instrument of Evil
024 Gagalout, Spiritual Supernatural Being
030 Meestri, Magical Fairy
036 Neptuzoys, A God

043 Nature and Origin

044 Alganar, Plant Origin
048 Krazostrich, Animal Origin
052 Fank, Earth Element
056 Showfleed, Air Element
060 Bubblehead, Water Element
064 Flamol, Fire Element
068 Cibernitte, Robotic Artificial Origin
072 Lasertag, Laser Artificial Origin
076 Gumore, Gum Artificial Origin
080 Jnopxylz, Alien Origin

087 Evolutions and Involutions

088 Batbirtt & Vampbirtt, Evolution
094 Pechi, Yochi & Granchi, Double Evolution
100 Shifmoron & Emoron, Involution
106 Gravelle & Rockus, Fusion
112 Salkovon & Minisalks, Fragmentation
118 Dallur & Esapta, Possession
124 Wedo & Neurowedo, Intellectual Evolution

131 Environment, Angles and Perspective

132 Brozzer, Location and Environment
140 Stack, Perspective
148 Bigey, High Angle Shot
156 Viros, Low Angle Shot
164 Cutebot, Rotations and Animation
174 Gumore, Facial Expressions

176 Acknowledgements

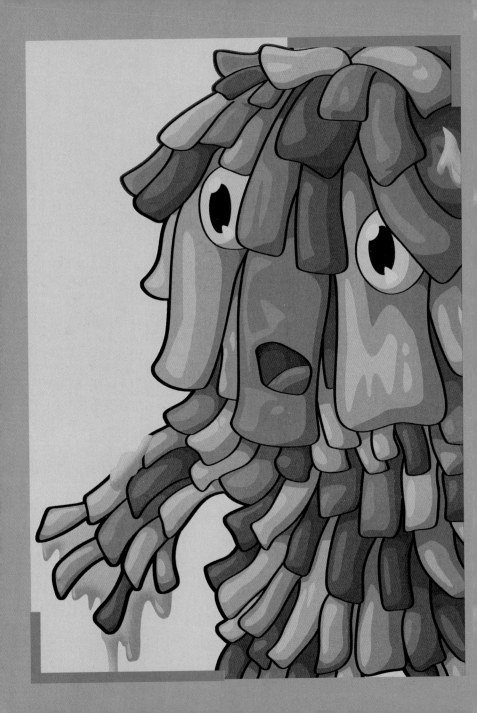

INTRODUCTION

Welcome to the fascinating world of chibis. This book will explain how to think up, draw and colour these equally hideous and attractive little characters who enjoy a huge legion of fans around the world. Let me take you on a journey of the fantastic world of Chiwelland inhabited by amazing and surprising creatures.

This guide has been adapted to suit both those who use computer programs and those who prefer a more traditional style of drawing, i.e. pencils, nibs, watercolours, etc.

On this journey we will review the basics of drawing, applied to the world of chibis, and we will gradually progress to more complex exercises. We will also create environments and explain the proper use of angles and perspective.

I hope that you enjoy this book and that you find it useful.

Sergio Guinot

GENERAL COMMENTS I: OUTLINE AND SKETCHING

Chibis are small, childlike characters who are drawn with distorted proportions. The head and the eyes of chibis are huge in proportion to their body. The body, arms and legs are shorter and the fingers are small or don't exist at all.

When sketching, don't be satisfied with the first attempt. Do as many sketches as you need. The sketch does not have to be perfect, but should include all elements of the final illustration.

GENERAL COMMENTS II: PENCILLING AND INKING

You can apply ink by hand with a nib, brush or pens, or by computer, scanning your pencil sketch and using graphics programs like Photoshop or Illustrator. This book will teach you to use and apply various types of line (smooth, curved, pointed, jagged, thick, fine). You will also learn to use coloured inks and how to remove them when they are not needed.

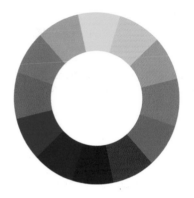

GENERAL COMMENTS III: COLOUR

When colouring, simplicity is the best policy. Some of the best manga characters combine only two or three colours.

An effective trick to achieve striking colours and contrasts is to combine any colour with its chromatic opposite on the colour wheel, such as green and violet. Good results are also achieved when you use only cool colours (blue and green) or hot colours (red, orange and yellow). Many examples are illustrated throughout this book.

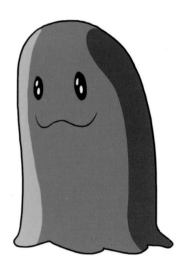

GENERAL COMMENTS IV: LIGHTING, SHADING AND FINISHING TOUCHES

A simple rule to apply light and shade, in particular if using a computer, is to add a touch of light (transparent white) to the side of the face that is looking towards the light source and shadow (black transparent) to the other. For a better understanding of light and shade, in this example I have separated the two on a layer of grey so that you can better understand and apply them.

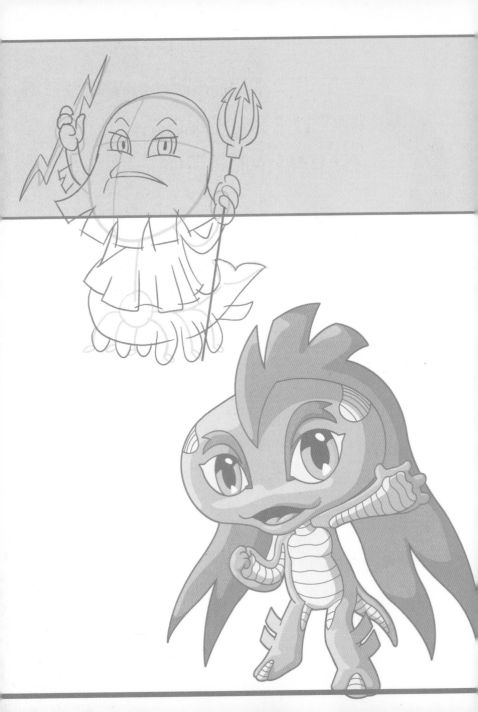

THE ETERNAL BATTLE BETWEEN GOOD AND EVIL

For centuries, the inhabitants of planet Chiwelland have lived in peace. But a terrible dark force threatens to destroy their planet. Some chibis, such as Sxlap, have decided to serve as instruments of evil. The evil hordes' greatest desire is to seize the Mesysula jewel, to pervert its incredible power and plunge Chiwelland into darkness and chaos. However, the powerful relic is kept in the temple of Kabiti and guarded by the Defenders of Good. These Defenders, led by Tarkano, are determined to protect the precious gem.

This unique planet has several supernatural presences that indirectly influence the outcome of this epic battle between good and evil. Among them are the mysterious race of the Gagalout, spiritual supernatural beings who live in space and travel from reality to a dream world.

TARKANO
DEFENDER OF GOOD

Defender of Good
Animal origin
Does not evolve
Amphibian
Amazing strength
and speed

Practice: Creating the character
Colour selection
Lighting and shading

1. OUTLINE AND SKETCHING

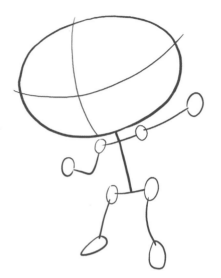

The basic outline of a chibi is used: a huge head and very small body, to which you add a few non-human details like a tail or fins. The crest and hair give the character personality.

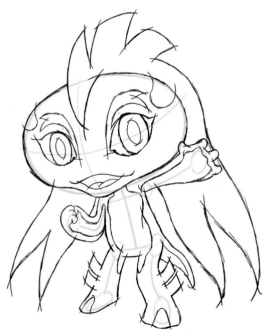

2. Inking

Use clean inks. The inks used for outer lines are always thicker than those used for inner lines. The lines of the body, arms and tail give the character an almost reptilian look. The spiky hair contrasts with the rounded body.

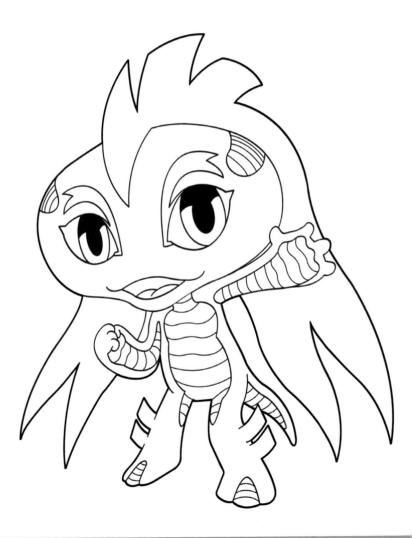

3. Colour

The green and yellow tones used on the body are characteristic of reptiles and amphibians. Violet is used for the hair as a contrast; it is the opposite of green on the colour wheel.

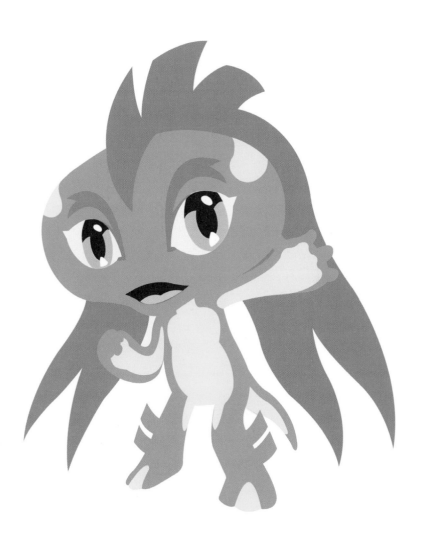

4. Lighting and Shading

Place the layer of light (transparent white) to the side of the face, towards which the character's head is turned. Don't worry which way the eyes are looking. The shading (black transparent) should be applied to the opposite side.

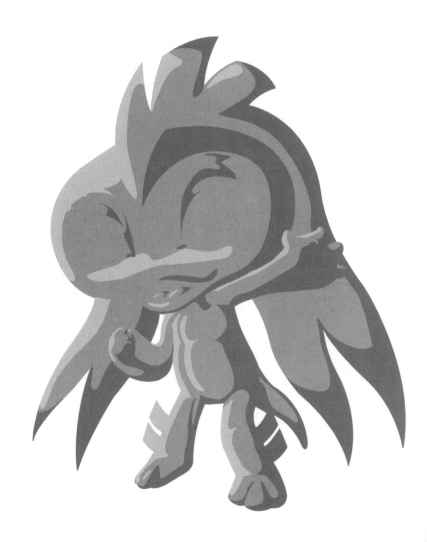

5. Finishing Touches

Tarkano is the leader of the Defenders of Good. Thanks to his noble character and vast wisdom, he is loved by all his friends and respected by his enemies.

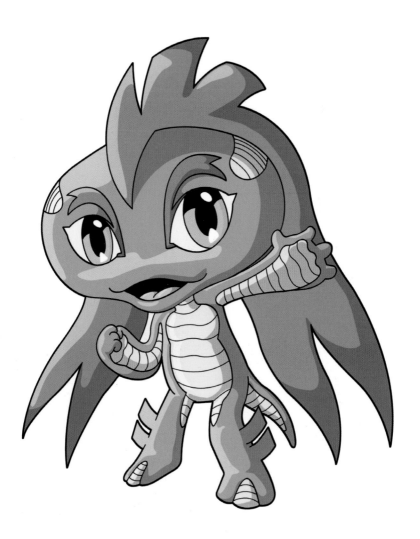

SXLAP
INSTRUMENT OF EVIL

Instrument of Evil
Animal origin
Does not evolve
Can fly

Practice: Creating the character
Use of warm colours
Double shading

1. Outline and Sketching

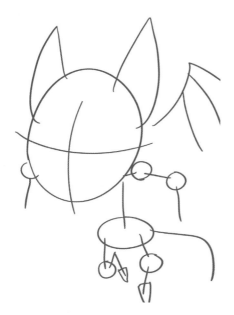

Add a tail, big ears and wings to the outline of a regular chibi (big head and tiny body). In the sketching stage, draw a mask with matching gloves and boots, a snout and a thick fox tail.

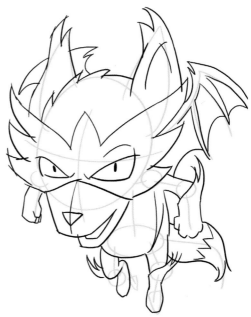

2. INKING

By applying ink you can add a few finishing touches to the character, such as the marks on the forehead and the gloves, or the lines on the tail and boots. Thick lines on the eyes reflect his evil side.

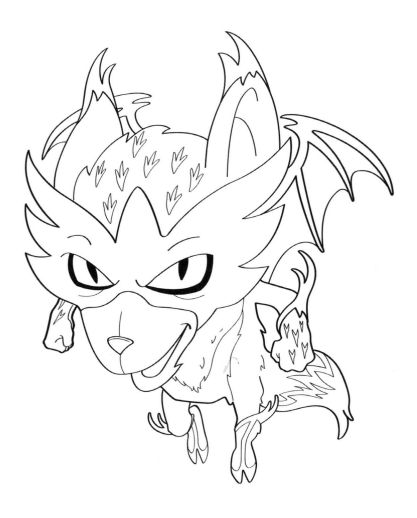

3. Colour

Use only warm colours for Sxlap. Remember to use stronger colours, such as red, for small and specific details. Use weaker colours such as orange and brown to cover larger areas.

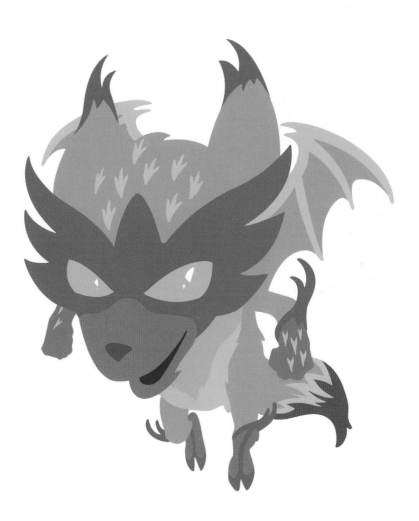

4. Lighting and Shading

Although you apply only one layer of light, use two layers of shade, one finer than the other, to add volume and a more pronounced aspect. This effect can be seen clearly on the tail and mask.

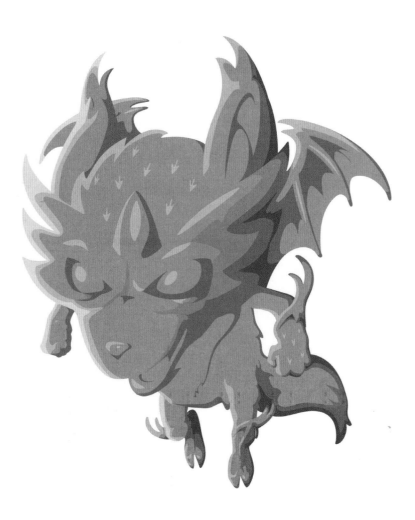

5. Finishing Touches

Sxlap is the ideal messenger for the forces of evil. He is ruthless and cunning. His twisted and evil plans are a constant problem for the Defenders of Good.

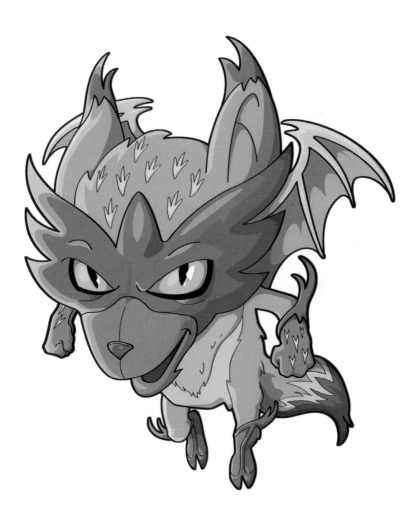

GAGALOUT
SPIRITUAL
SUPERNATURAL BEING

Defender of Good
Supernatural origin
Does not evolve
Travels from the physical to the
spiritual plane

Practice: Creating the character
Double lighting and shading

1. OUTLINE AND SKETCHING

Gagalout is different from the chibis we have seen so far as he has four arms and no legs. Give him a ghost-like body and a curiously shaped head.

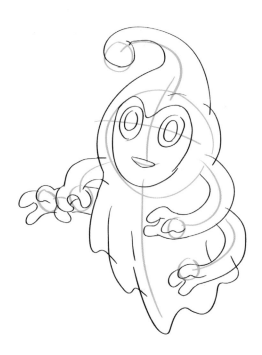

2. INKING

Do not apply too much ink to
Gagalout – just a few curved lines
and a few angles. The ink used for
the outer lines should be thicker
than the ink used for the inner lines.

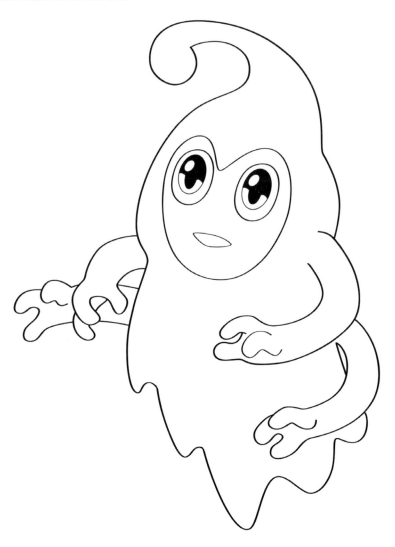

3. Colour

I chose a light blue colour for the body, in keeping with Gagalout's pleasant character. The dark blue used for his face gives him a mysterious edge and the red eyes add a slightly supernatural and disturbing look.

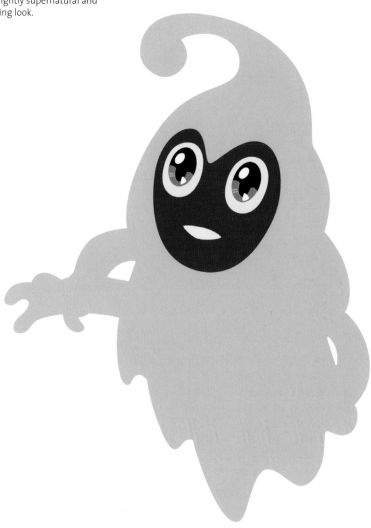

4. Lighting and Shading

I have complicated the exercise slightly by adding two layers of light and two layers of shade, both semi-transparent. This is the perfect technique for characters with little detail on their body or clothing.

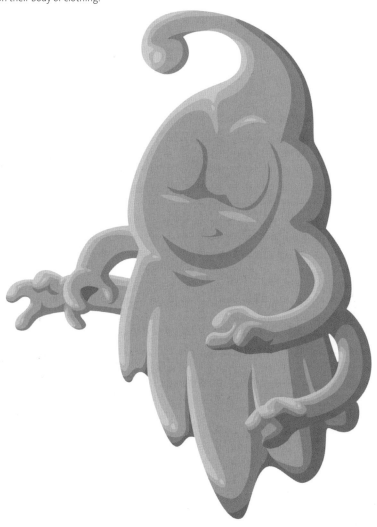

5. FINISHING TOUCHES

Gagalout is an immortal spirit. Although he is not very powerful and rather innocent, he is a loyal friend who is always there when you need him.

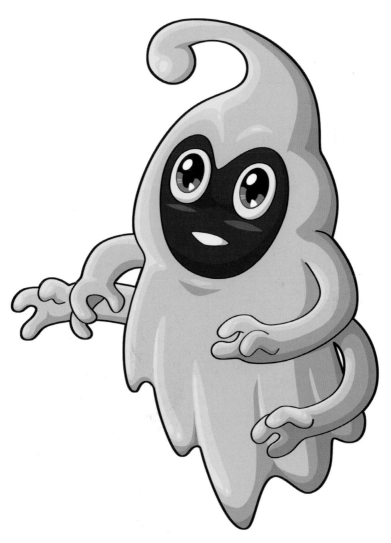

MEESTRI
Magical Fairy

Fairy
Magical origin
Does not evolve
Can magically alter reality

Practice: Creating the character
Magical lighting and shading

1. OUTLINE AND SKETCHING

The sketch consists of a huge oval head and butterfly wings. Add a lot of detail to the head and wings. Give the character a feminine shape.

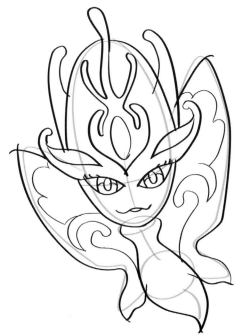

2. INKING

The lines must be curved and
elegant. The contour of the eyes
outlined in black gives the fairy a
suggestive gaze that hides a world
of impossible wonders.

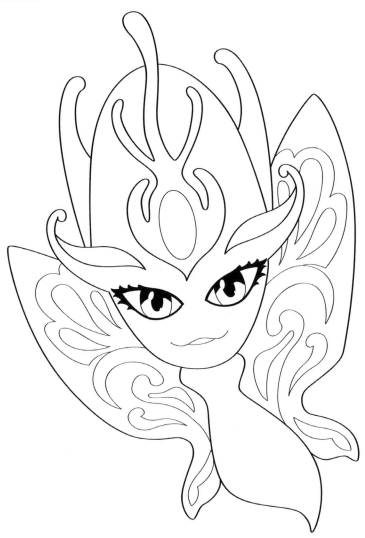

3. COLOUR

I have chosen typically feminine colours. The combination of pinks and violets softens the aspect of the character.

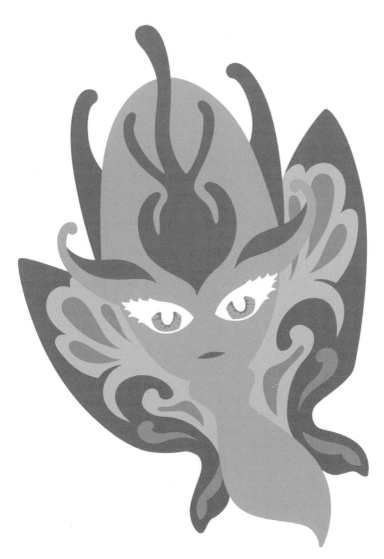

4. LIGHTING AND SHADING

To convey the magical essence of
Meestri, use two layers of lighting
that are in the form of bubbles. The
layers of shading do not add volume.

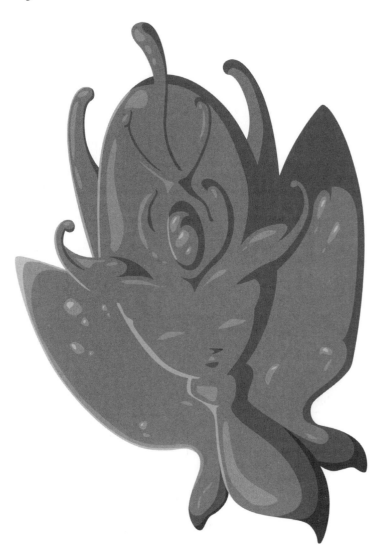

5. Finishing Touches

Meestri is one of the most beautiful beings in Chiwelland, however that does not mean she is weak or helpless. Her magical powers are unimaginable.

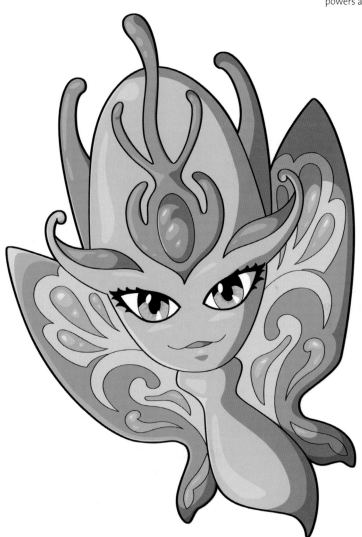

NEPTUZOYS
A God

Divinity
Divine origin
Does not evolve
God of the sea and sky

Practice: Creating the character
Special effects

1. OUTLINE AND SKETCHING

To create a strange and complex god, use the head and arms of a typical chibi and add the body of a fish with six legs. A lightning bolt and a trident are the symbols of his power. The tunic gives him the aspect of a Greek god.

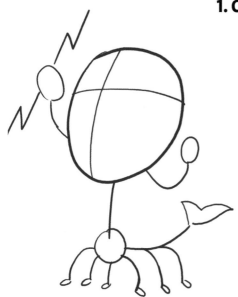

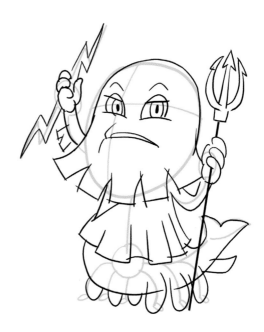

2. INKING

Add a few details that do not appear in the outline, such as jewellery and a laurel crown, to give Neptuzoys a more grandiose appearance.

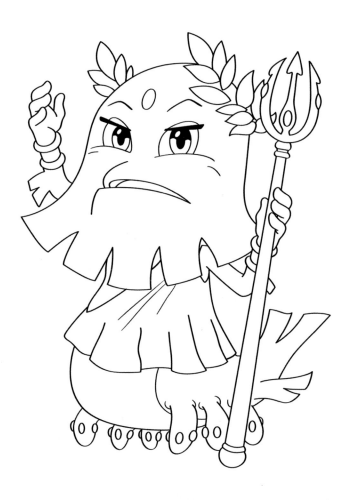

3. Colour, Lighting and Shading

I have chosen a sea blue colour. His accessories are made of gold to give him a more divine aspect. Green is a mixture of blue and yellow, as can be seen in the colour wheel. Lighting and shading are basic concepts that have already been mentioned.

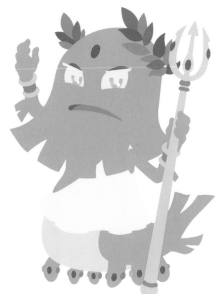

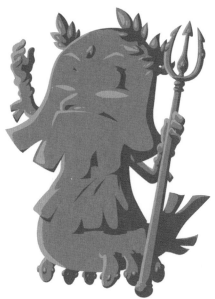

4. Special Effects

To create the lightning bolt, use yellow paint as a base, then colour the middle part with a lighter yellow. Finally, surround the ray with a very transparent yellow layer.

5. FINISHING TOUCHES

From the sea to beyond the heavens, Neptuzoys watches over all the inhabitants of Chiwelland. His proud gaze reflects his unlimited power, above and beyond good and evil.

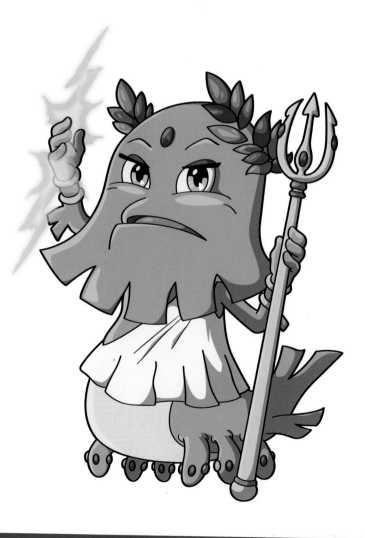

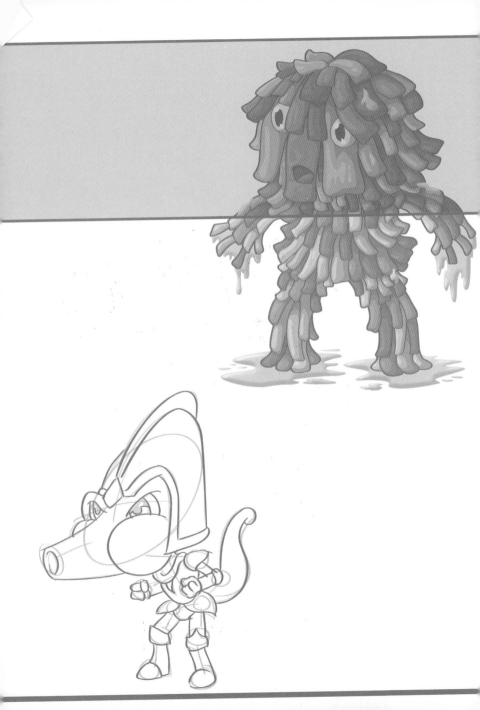

NATURE AND ORIGIN

When the god Neptuzoys created the lightning bolt that bestowed upon him the title of Lord of all the Inhabitants of Chiwelland, its sparks fell on the four elements (earth, air, water and fire), forming the ancient chibis. Earth chibis evolved into creatures made from rock and mud. Air chibis possessed the capabilities to control winds, hurricanes, storms and gales. In the sea, the chibis could control water, rain and waves. Fire chibis dominated spark and flame.

Over the centuries, some water chibis surfaced, and by feeding on plants and animals, evolved into chibis of plant and animal origin. A thousand years later, the chibis learned to master technology and created artificial beings from substances such as laser or gum. We know chibis exist on other planets, although on planet Chiwelland very few have had contact with alien beings.

ALGANAR
PLANT ORIGIN

Defender of Good
Plant origin
Does not evolve
Seeks camouflage in murky waters

Practice: Creating the character
Viscous liquids

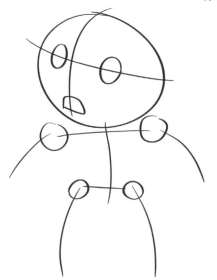

1. OUTLINE AND SKETCHING

The outline is typical of a chibi (large head, small body). The sketch is complex because Alganar is made from algae from head to toe. With patience, draw each piece of alga one by one.

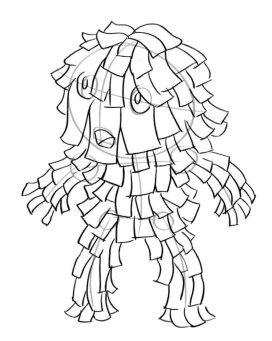

2. INKING, COLOURING, LIGHTING AND SHADING

With well-defined inking and a mixture of various shades of green you can achieve a visually appealing character. A hint of light and shade on each piece of alga gives a good sense of volume.

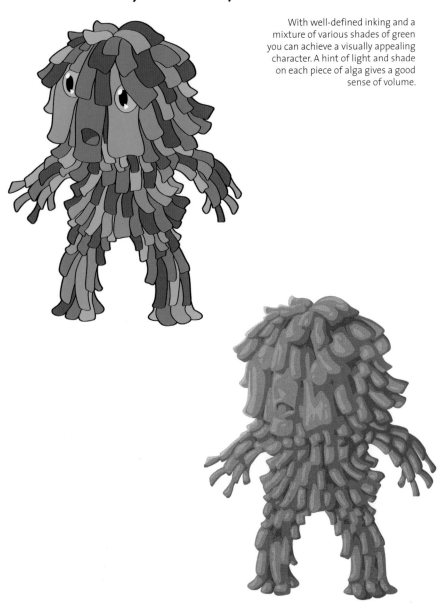

3. Finishing Touches

Finally, add a little viscous liquid.
This can be done easily using
light green droplets to which
defined lighting and gradated
shading are added.

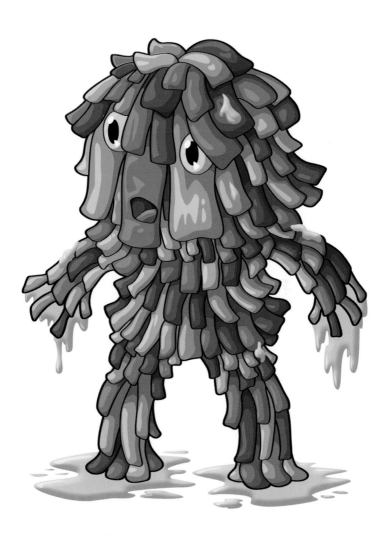

KRAZOSTRICH
ANIMAL ORIGIN

Instrument of Evil
Animal origin
Does not evolve
Crazy and dangerous

Practice:
Creating an animal-like chibi

1. Outline and Sketching

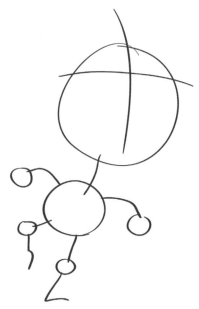

Here, the concept of a chibi is applied to the anatomy of an ostrich. She has a huge head and small body but with two long legs. The strange tail and plant-like accessories to the neck and eyes give her a reckless and festive look.

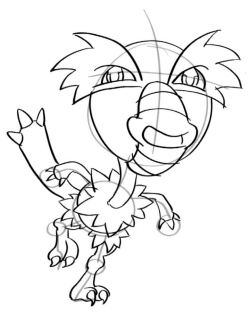

2. INKING, COLOURING, LIGHTING AND SHADING

The inking combines curves with sharp angles and the colours clash to create a crazy character. The lighting and shading once again provide the required volume.

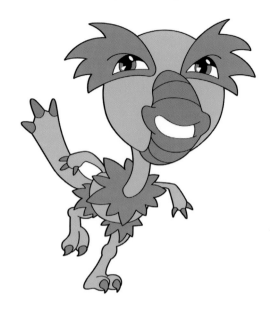

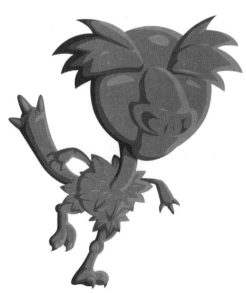

3. Finishing Touches

The many shapes and sizes in the animal kingdom is a source of limitless inspiration. Distorting their features can give you results as unusual and wild as our colourful ostrich.

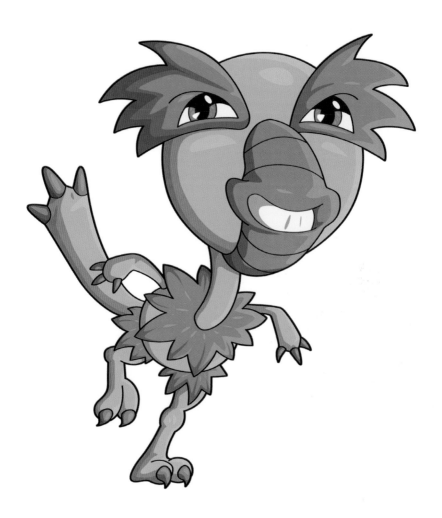

FANK
EARTH ELEMENT

Instrument of Evil
Earth element
Does not evolve

Practice: Creating the character
How to draw a mud creature
Special use of lighting and shading

1. OUTLINE AND SKETCHING

Use the typical outline of a chibi as a starting point. In the sketching stage, add blue eyes and a huge mouth. He is covered with large drops of mud that hang from his body.

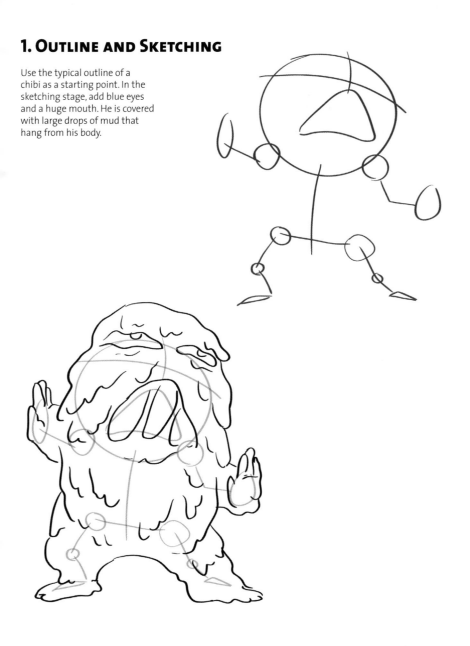

2. Inking, Lighting and Shading

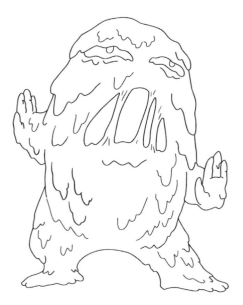

The top and bottom part of his mouth are joined together to convey a heightened muddy effect. Shading on the side of the face, which is looking towards the light source, makes the character seem even more sad and tormented.

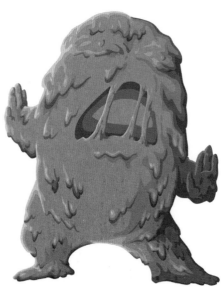

3. Colour and Finishing Touches

I chose a yellowish brown colour
for the mud. The red eyes do
not fully portray the evil nature
of this powerful, obsessive and
dangerous character.

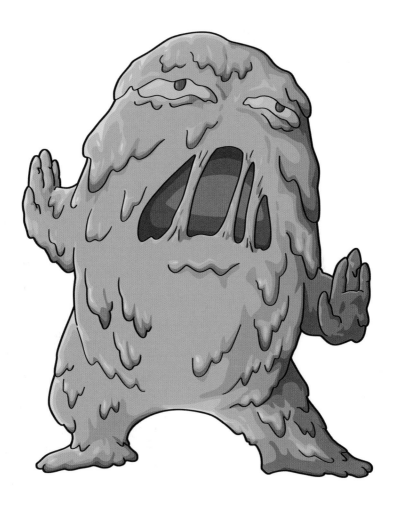

SHOWFLEED
Air Element

Defender of Good
Air element
Does not evolve
Forceful blow

Practice: Creating the character
Classic sources of inspiration

1. OUTLINE AND SKETCHING

Change the outline of a typical chibi to a cone-shaped mouth and a curly tail. Sketch Showfleed blowing with all his strength and wearing heavy armour.

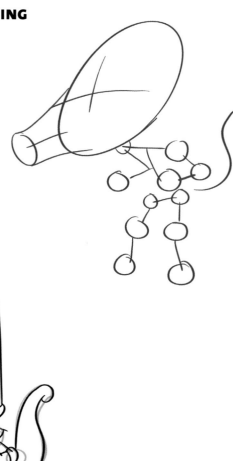

2. Inking, Colouring, Lighting and Shading

The inking is clean and defined. The colours of the armour are classic and the skin tone reminds us that this is an air character. The use of light and shade provide the required volume.

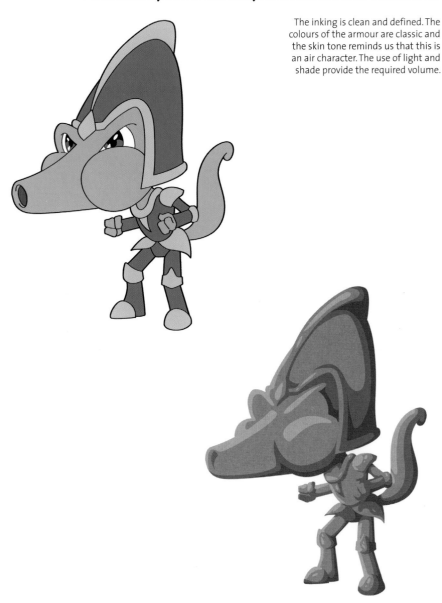

3. Finishing Touches

Use a wide range of sources of inspiration. Although stories of knights in shining armour are very old, using these elements with modern chibis can achieve surprising results.

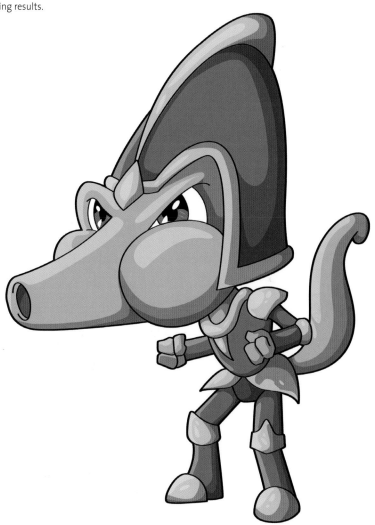

BUBBLEHEAD
WATER ELEMENT

Instrument of Evil
Water element
Does not evolve
Dominates water

Practice: Creating the character
How to draw water in motion
Use of coloured inks
Using transparencies

1. Outline and Sketching

Bubblehead is a drop of water that travels in a bubble. Imagine a jet of water that can then adopt any shape you want. Two ellipses are used, a whirlpool-like shape and two arms.

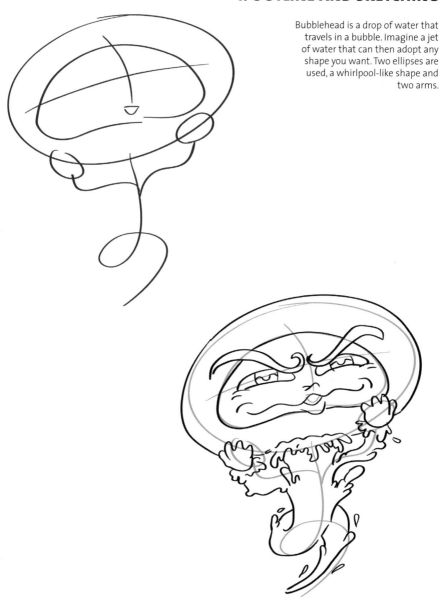

2. INKING, COLOURING, LIGHTING AND SHADING

Use black ink for the character, and blue and white for the water and foam. The yellow detail provides the necessary contrast. The use of light and shade add volume.

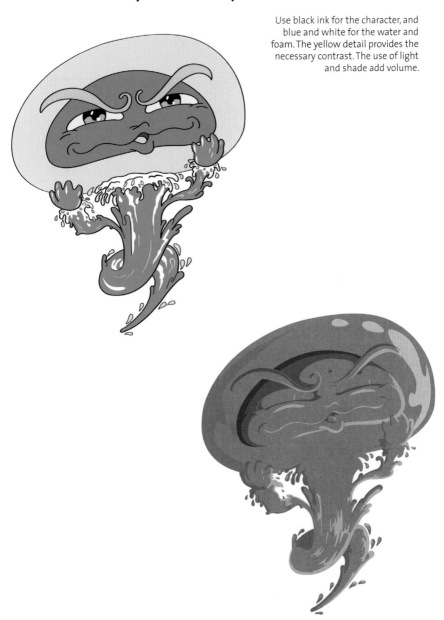

3. Finishing Touches

Use blue ink, slightly darker than the colour of water. Do not use ink for the foam, and add a layer of low-opacity blue to the bubble so that the head appears inside it.

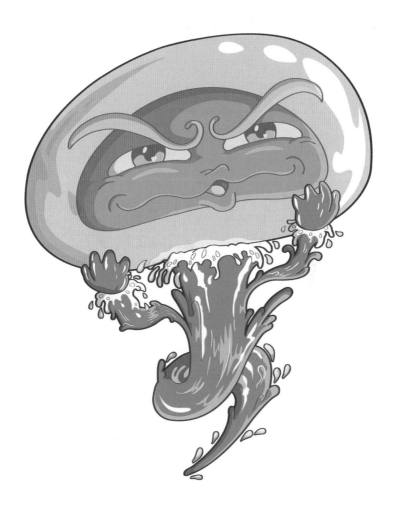

FLAMOL
FIRE ELEMENT

Defender of Good
Fire element
Does not evolve
Dominates fire

Practice: Creating the character
How to draw fire

1. OUTLINE AND SKETCHING

In this case, the classic outline of a chibi is complemented with horns and a tail. In the sketching stage, the enormous crest of fire stands out, indicating the origin of the character.

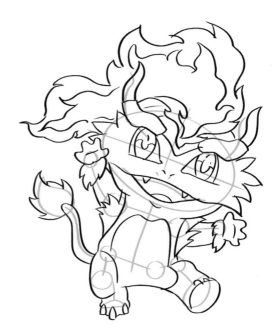

2. Inking, Colouring, Lighting and Shading

Angular lines and warm colours are mainly used for Flamol. The blue in his eyes and horns balance the character both visually and emotionally. The use of light and shade add volume.

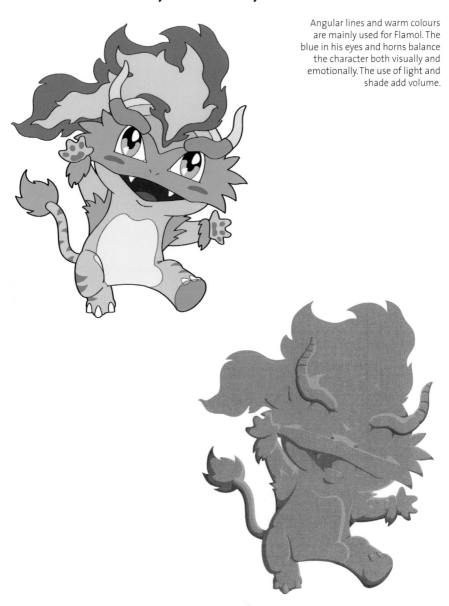

3. Finishing Touches

Remove ink from the yellow,
central part of the fire. Lighting has
been added to the centre of the
forehead and face. Flamol is a very
charismatic character.

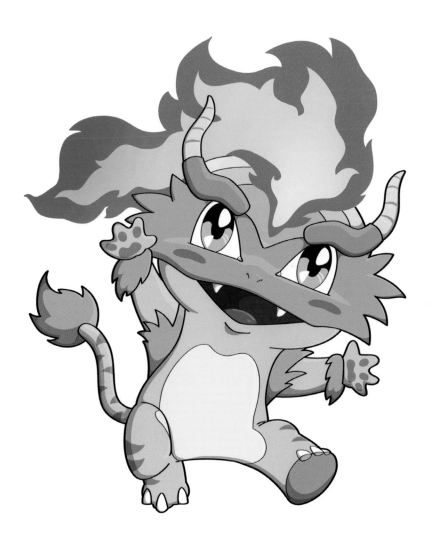

CIBERNITTE
ROBOTIC ARTIFICIAL ORIGIN

Instrument of Evil
Robotic artificial origin
Does not evolve
Submarine spy

Practice: Creating the character
How to convert characters
into robots

1. Outline and Sketching

The outline of Cibernitte is based on an ammonite for the head and a seahorse for the body. The sketch highlights the tentacles beneath the mouth of the character.

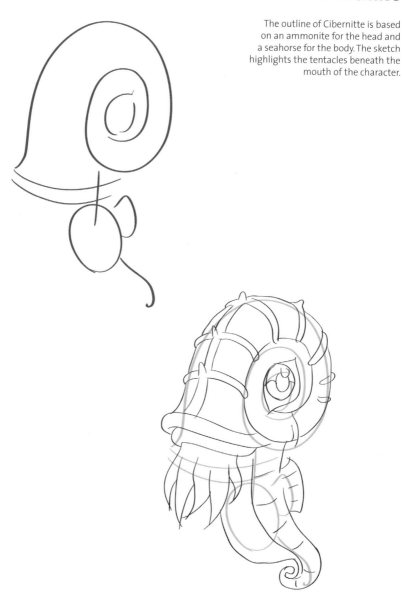

2. Inking, Colouring, Lighting and Shading

Thick lines are used on the outside of the character and finer lines for the inner elements. The colours of the head contrast with the rest of the body. Use layers of lighting and shading to add volume to the drawing.

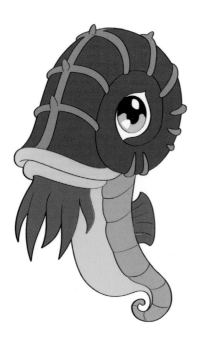

3. FINISHING TOUCHES

With a few simple inner details we can create metal screws and plates. In this way you can easily transform an organic creature into a robot.

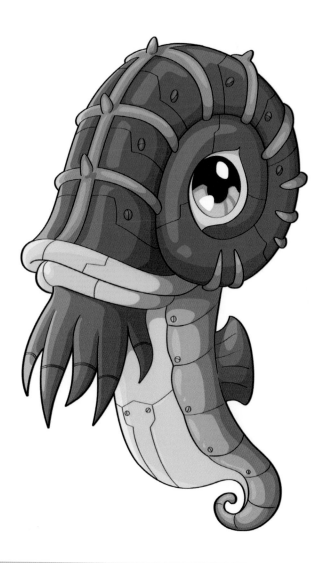

LASERTAG
LASER ARTIFICIAL ORIGIN

Defender of Good
Artificial laser origin
Does not evolve
Moves at the speed of light

Practice: Creating the character
Drawing without ink
Effects of light

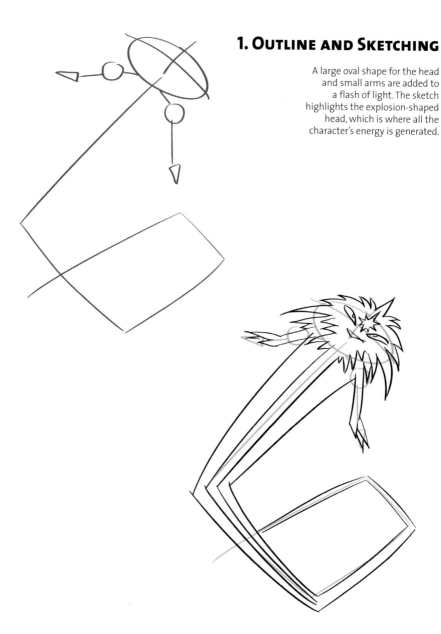

1. OUTLINE AND SKETCHING

A large oval shape for the head and small arms are added to a flash of light. The sketch highlights the explosion-shaped head, which is where all the character's energy is generated.

2. Inking, Colouring, Lighting and Shading

We are looking to achieve a strange and artificial colour. Lighting and shading and the lack of ink help us to emphasize that Lasertag is pure light and pure energy.

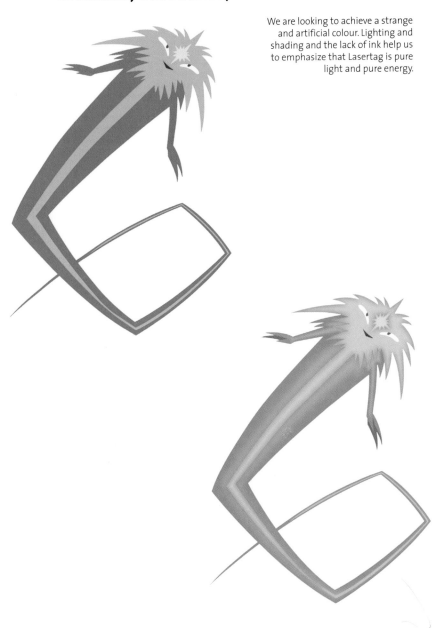

3. FINISHING TOUCHES

The tremendous speed of Lasertag lets him travel anywhere in Chiwelland in an instant. Lasertag's greatest enemies are water and darkness.

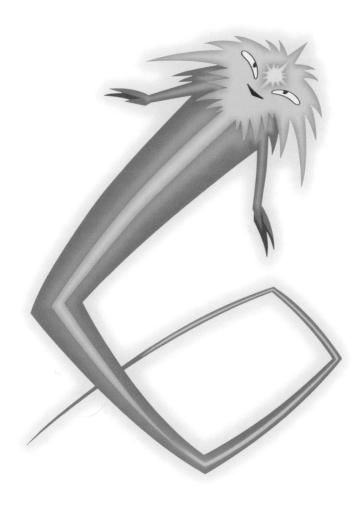

GUMORE
Gum Artificial Origin

Defender of Good
Artificial gum origin
Does not evolve
Very flexible outlook

Practice: Creating a character with
no body or limbs

1. OUTLINE AND SKETCHING

Sketch a large circumference for the head and smaller circumferences for the short tentacles. The sketch highlights the facial expression that dominates the entire body.

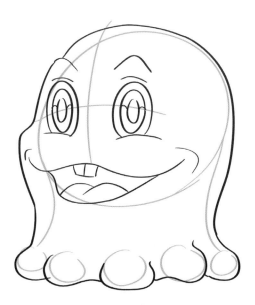

2. Inking, Colouring, Lighting and Shading

The inking is very homogeneous, just like the colouring. The eye colour provides contrast. The use of light and shade defines the volume of the few interior elements.

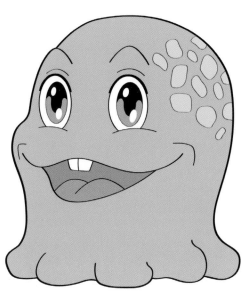

3. Finishing Touches

Both his physical characteristics and his personality make Gumore a very adaptable and versatile character, who is able to resolve the most difficult situations.

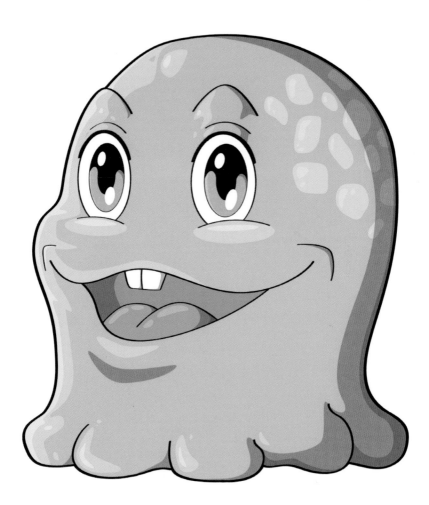

JNOPXYLZ
ALIEN ORIGIN

Defender of Good
Alien origin
Does not evolve
Knowledge of advanced space
technology

Practice: Creating an
alien-looking character

1. OUTLINE AND SKETCHING

Outline Jnopxylz with a small body, large head and two enormous eyes. In the sketching stage, the kind expression of the character stands out, owing to its big eyes.

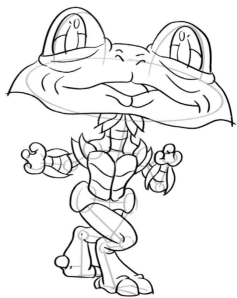

2. INKING

Thicker lines are used on the outside
and finer lines are used to define
the mouth, nose or any of the many
details of the character's body.

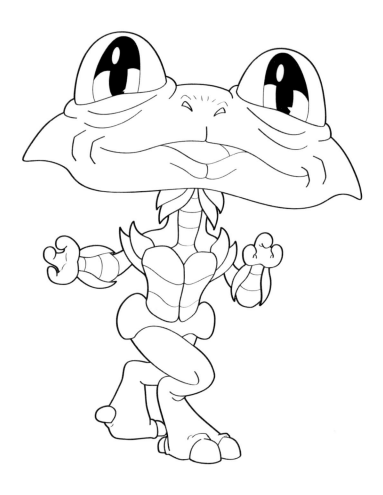

3. Colour

Use warm colours to reflect
Jnopxylz's friendly and cheerful
personality. Three different colours
are used to distinguish the
elements and textures. The blue
eyes act as a contrast.

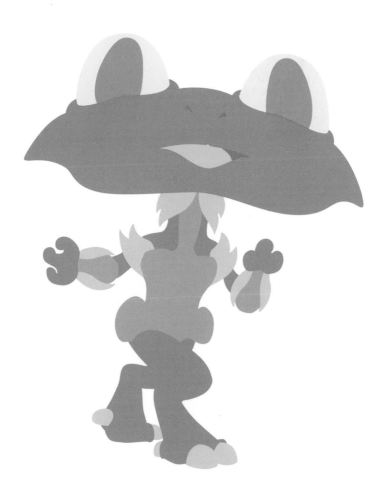

4. Lighting and Shading

By using two layers of lighting and shading, add more definition to the character's various elements and give him more volume.

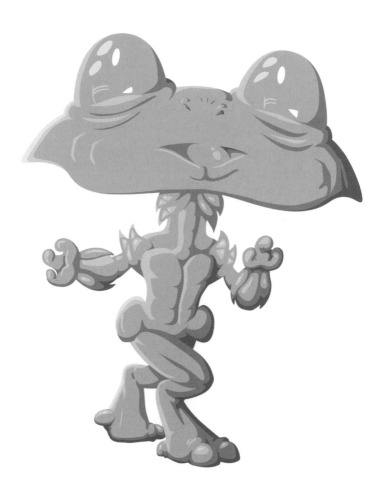

5. Finishing Touches

Jnopxylz is not native of Chiwelland.
He is an alien from the planet Kog
and travels through space to help
the good forces in need of his help.

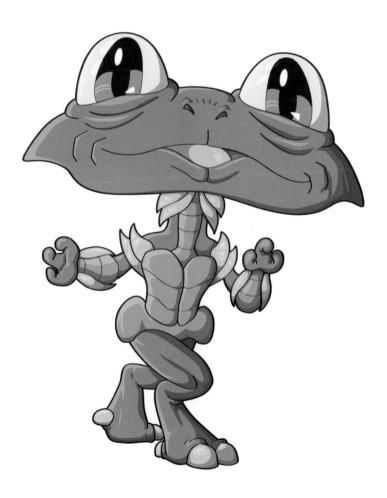

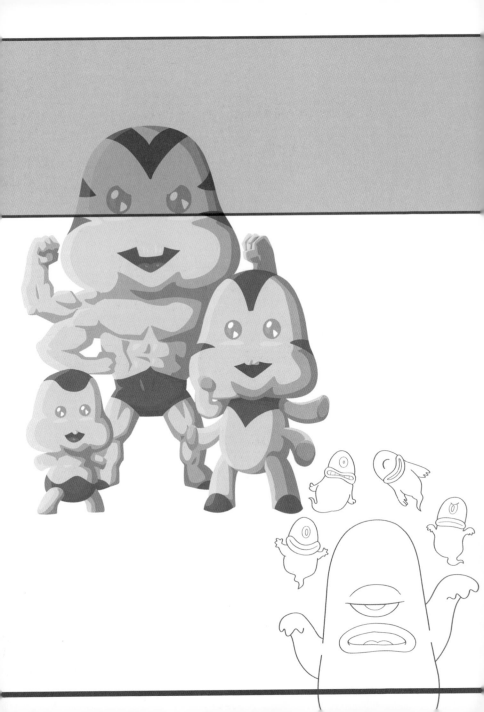

EVOLUTIONS AND INVOLUTIONS

Some of the beings that live in Chiwelland can voluntarily change their anatomy and even their powers temporarily, and then return to their natural state. The chibis that change through evolution multiply their strength significantly. Usually they adopt a more ferocious image to frighten their enemies.

Some of the planets' inhabitants have the power of Fusion, which allows them to merge several chibis into one single being. This power is sometimes confused with the chibis who govern fragmentation, as this is based on the division of the original character into smaller copies of him- or herself.

Possession is an extraordinary case in which the spirit of a chibi controls the body of another and gives them all their powers and magical abilities. Intellectual evolution is a strange event that only occurs in 1 in every 10,000 Wedos, as discussed later.

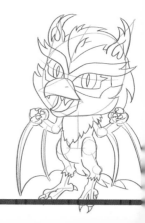

BATBIRTT & VAMPBIRTT
EVOLUTION

Instrument of Evil
Animal origin
Evolution of Batbirtt to Vampbirtt
His deafening scream can leave you
paralysed

Practice: Creating a chibi evolution

1. OUTLINE

In order to understand that this is the same character that evolves, not two different characters, both must share a similar anatomy, adapted to their size.

2. SKETCH

Give Vampbirtt the physical characteristics of the smaller Batbirtt but make them larger and more aggressive.

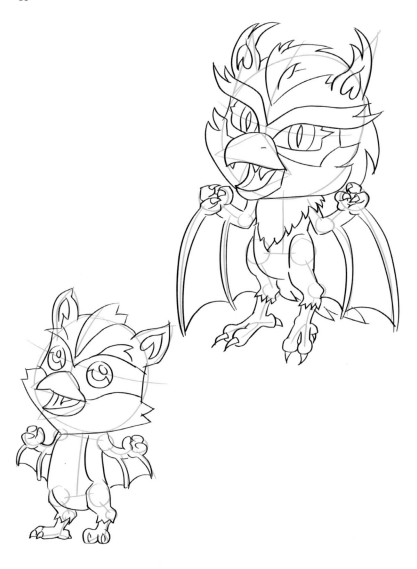

3. Inking and Colour

Give Batbirtt a softer appearance by applying the ink in curves, and Vambirtt a more angular look. The cool colours indicate that they are wicked creatures. The yellows and reds give the contrast that the characters require.

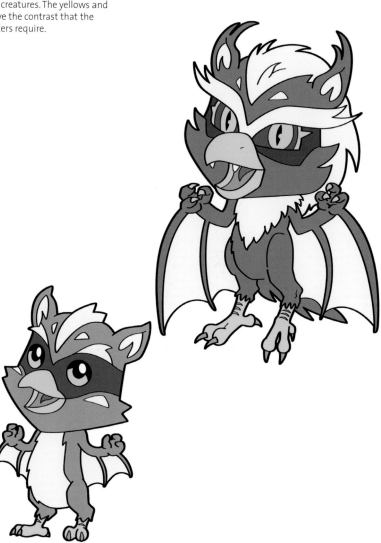

4. Lighting and Shading

The layers of light position the characters in relation to the light source. The shading creates volume. Use light to add detail to the chest of each chibi.

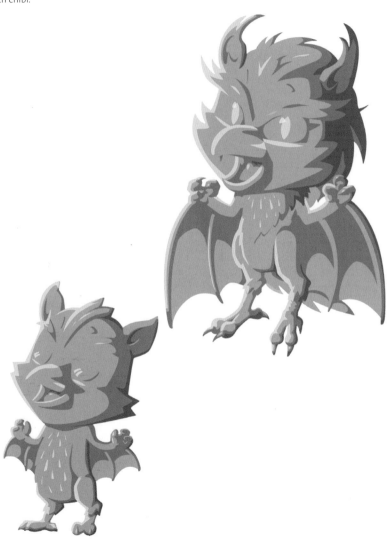

5. FINISHING TOUCHES

As a finishing touch, add a mysterious gleam to the eyes of Vampbirtt. No one could ever imagine that the precious Batbirtt conceals a dangerous personality.

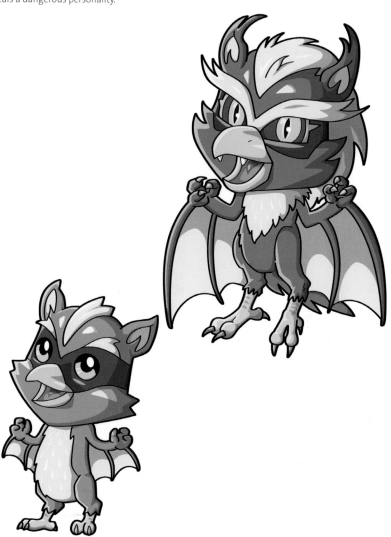

PECHI, YOCHI & GRANCHI
DOUBLE EVOLUTION

Instrument of Evil
Air element
Double evolution: from Pechi to
Yochi, and from Yochi to Granchi
Increase your strength with each
evolution

Practice: Versions of the
same character

1. OUTLINE AND SKETCHING

The outline for each size maintains the proportions between the head and body. The sketch will distinguish better the similarities and differences between the three characters.

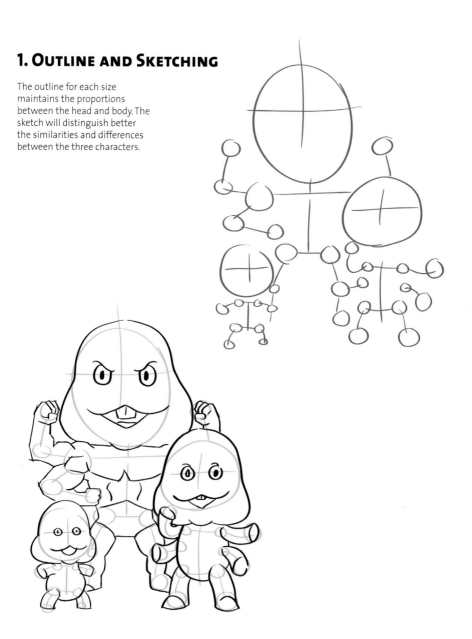

2. Inking

Use more curved lines for little
Pechi and more angular lines for
the gigantic Granchi, adding more
decorative details as the chibi grows.

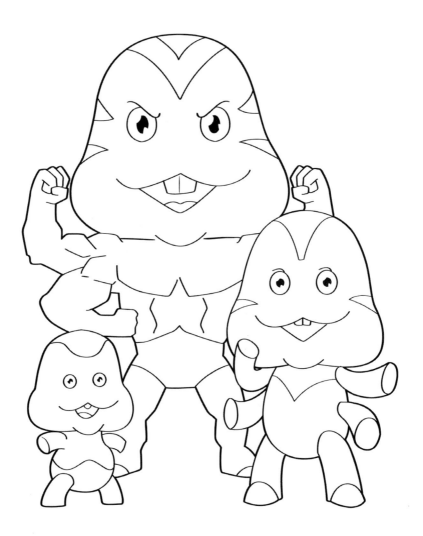

3. COLOUR

Use cool colours when sketching villains. Warm colours in the eyes and mouth are used as a form of contrast.

4. Lighting and Shading

Again, the layer of lighting positions our characters relative to the light source. Shading is used to create volume, especially in the muscular Granchi.

5. Finishing Touches

You have reflected the character at each stage of evolution. Pechi is more candid. Yochi is more playful. Granchi is more aggressive.

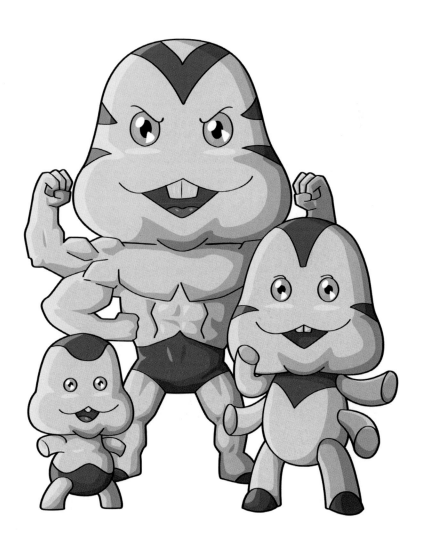

SHIFMORON & EMORON
INVOLUTION

Defender of Good
Animal origin
Involution: from the winged
Shifmoron to little Emoron
Shifmoron can fly and the feathers
on his wings have healing powers.

Practice: Creating an involutional
character

1. OUTLINE AND SKETCHING

The outline indicates the position of the wings and tails. Use the sketch to clarify the difference between the tail and hair of both chibis.

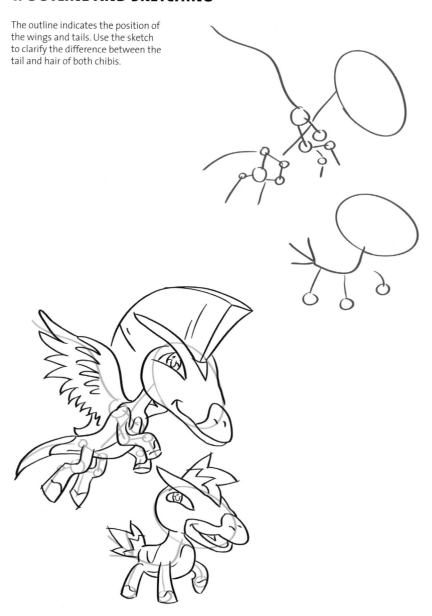

2. INKING

Use curved lines in both chibis. Even though Shifmoron is the adult, do not use angular lines to preserve the goodness of his character.

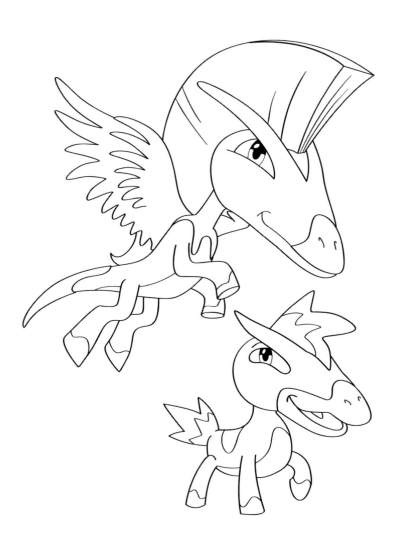

3. Colour

Orange shades are used to give joy to the characters and violets to add a touch of magic. Shifmoron's wings involute from Emoron's back.

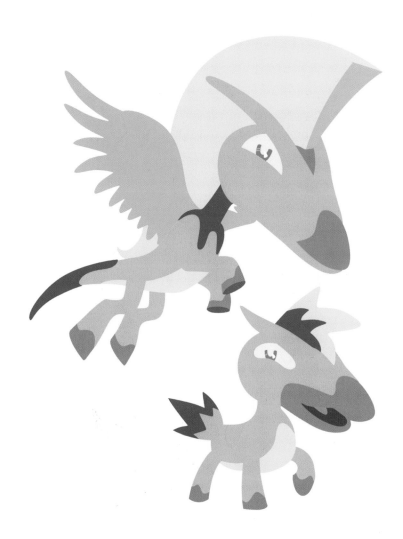

4. Lighting and Shading

Use lighting to highlight the faces of the characters, while the double layer of shading allow you to give volume to Emoron and Shifmoron.

5. Finishing Touches

Evil beings try to hunt Shifmoron
to tear his wings off and take
advantage of the healing powers of
his feathers, so when he wants to
go unnoticed, Shifmoron involutes
into Emoron.

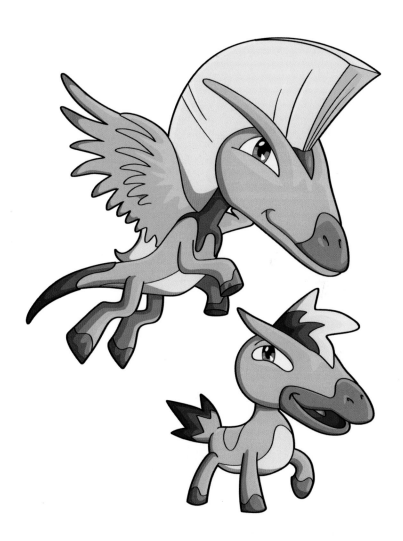

GRAVELLE & ROCKUS
Fusion

Defender of Good
Earth element
Evolution by fusion: from Gravelle
to Rockus
Colossal strength

Practice: Creating the character
How to draw characters from rock

1. Outline and Sketching

In the original outline, the arms
emerge from beneath Rockus
and his legs from the sides. In the
sketching stage, define each of
the stones.

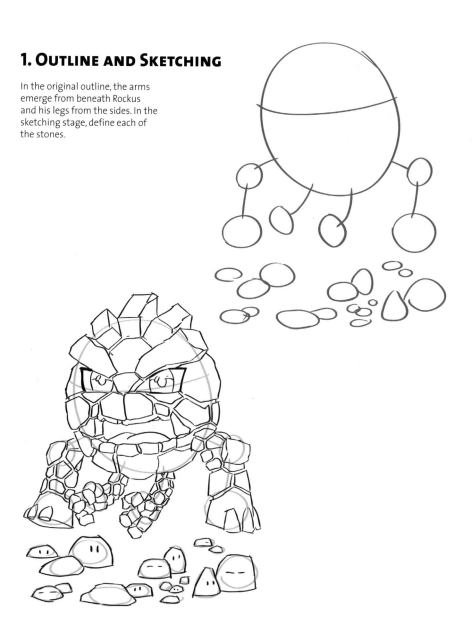

2. INKING

To draw rocks, use angular and rough lines and add a lot of surface texture. The thick lines around the eyes of Rockus give him a more fearsome appearance.

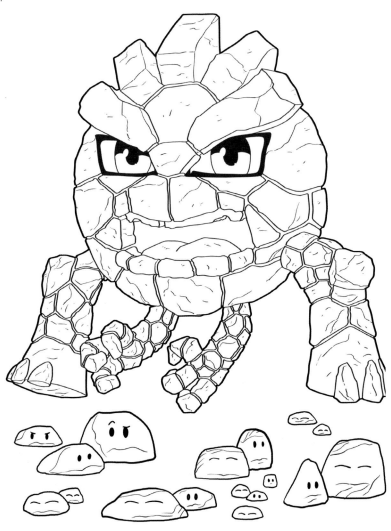

3. Colour

Use various shades of brown and grey to provide contrast. This allows us to better define each of the character's parts.

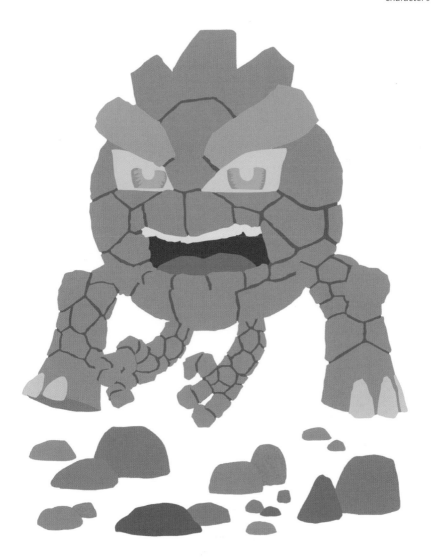

4. Lighting and Shading

Using the large amount of surface texture in the inking stage as a guide, have fun by highlighting the volume and roughness of each of the rocks.

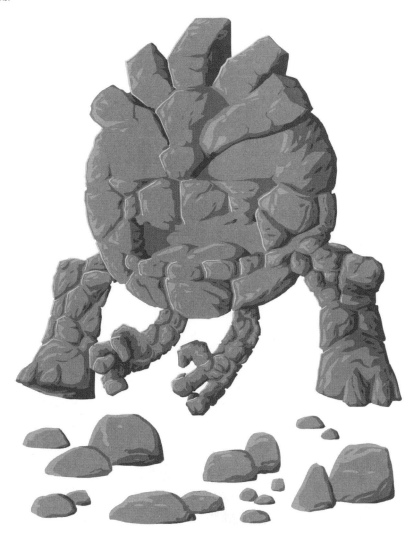

5. Finishing Touches

When someone wants to cross the Narabiti Bridge to enter the Kabiti temple, the stones on the path join together giving force to the almighty Rockus, who blocks the path of evil beings.

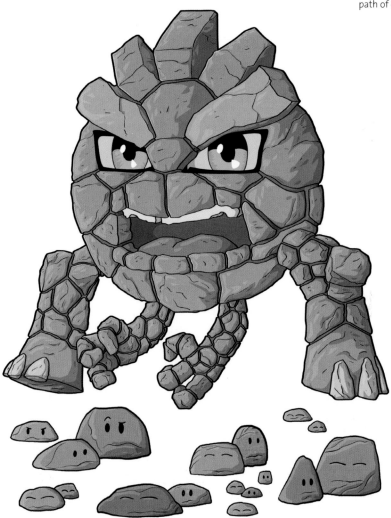

SALKOVON & MINISALKS
FRAGMENTATION

Defender of Good
Supernatural origin
Evolution by fragmentation:
from Salkovon to Minisalks
Go through solid materials and
possess hypnotic powers

Practice: Creating the character
Miniature versions

1. Outline and Sketching

In the outline, indicate the volumes of the heads, and mark the positions of the bodies and arms. In the sketching stage, define clearly the faces, bodies and hand gestures.

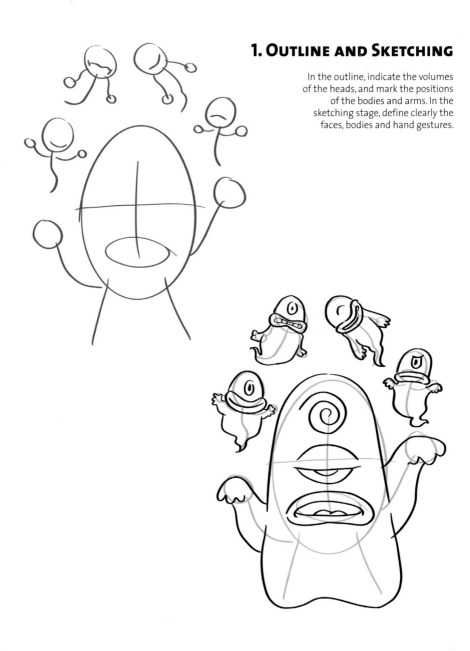

2. INKING

Thicker lines are used on the outside and finer lines for the inner elements. Use curved lines to give the chibis a friendlier aspect as they are spiritual creatures.

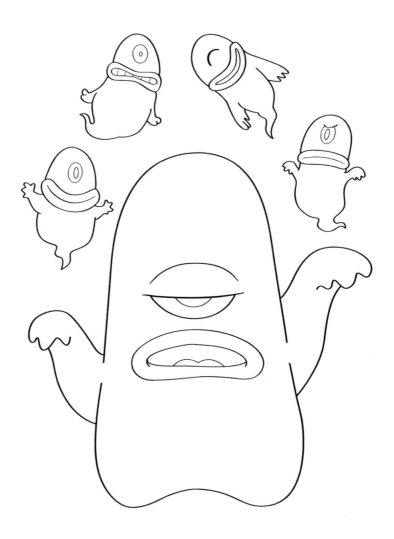

3. Colour

Use a blue-green tone for the body, contrasting with the red symbols and the large lips to add to the comical aspect of Salkovon and the Minisalks.

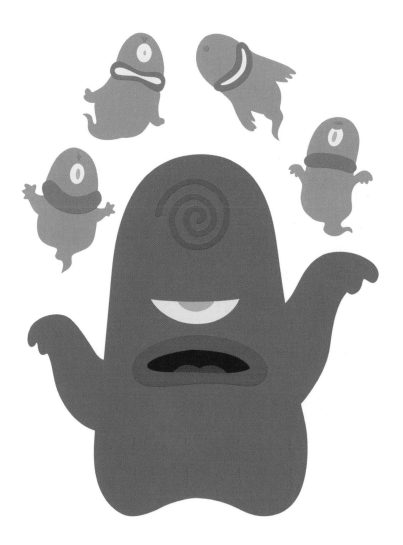

4. Lighting and Shading

The layer of lighting simply indicates the position of the light source. The volume of the characters is created by the three layers of shading, which gives them an air of mystery.

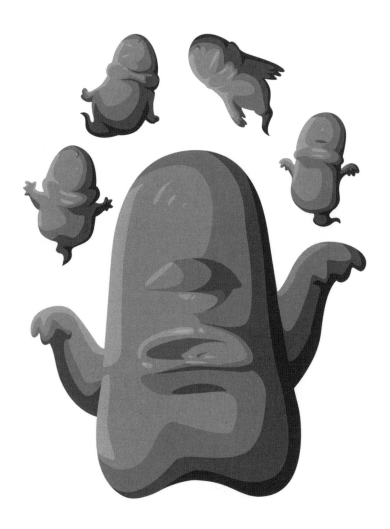

5. Finishing Touches

You should not be fooled by the appearance of these chibis. Salkovon seems the more threatening, but he is actually very quiet. The Minisalks, however, enjoy getting up to all sorts of mischief.

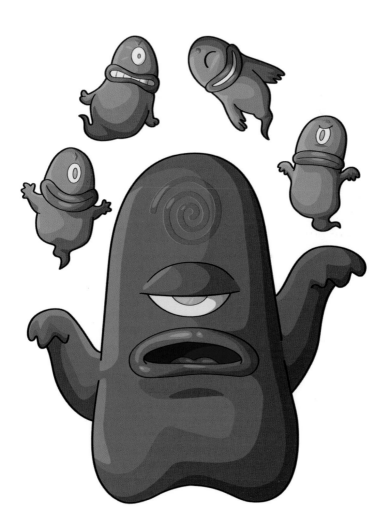

DALLUR & ESAPTA
POSSESSION

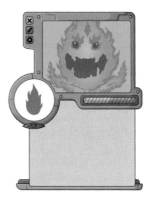

Instrument of Evil
Fire element
Possession
Dominates hellfire

Practice: Creating the character
How to create a magic fire

1. OUTLINE AND SKETCHING

In the basic outline, define the
position of the teeth. In the
sketching stage, completely cover
the character in flames and give him
a crazy look in his eyes.

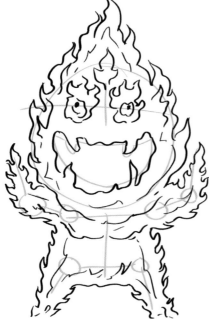

2. INKING

Use tapering wavy lines to represent the flames. The ink will be thicker on the outside of the character and when it is used to define specific parts of the body.

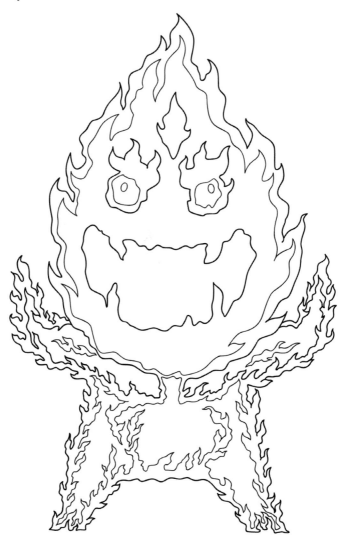

3. COLOUR

Use three shades of purple, which is a mysterious colour. It allows us to differentiate normal fire from hellfire, for which we always use red and yellow.

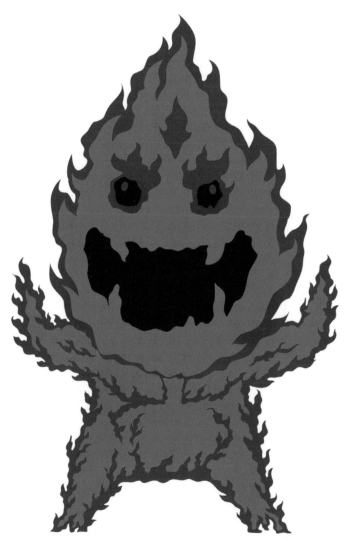

4. LIGHTING AND SHADING

Here there is a more intense light in the centre, getting weaker towards the outside. The centre of the fire is usually the point where energy is generated.

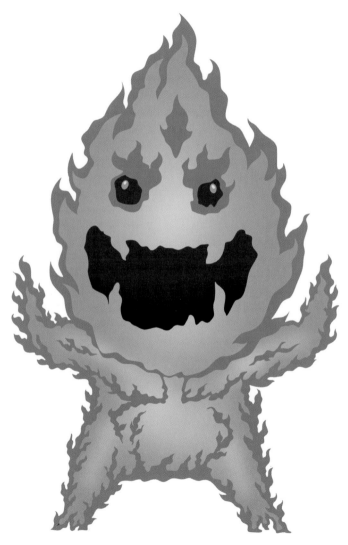

5. Finishing Touches

To represent Dallur's body of fire I removed lines of ink. Dallur was a Defender of Good, but he was possessed by the devil Esapta and became an instrument of Evil.

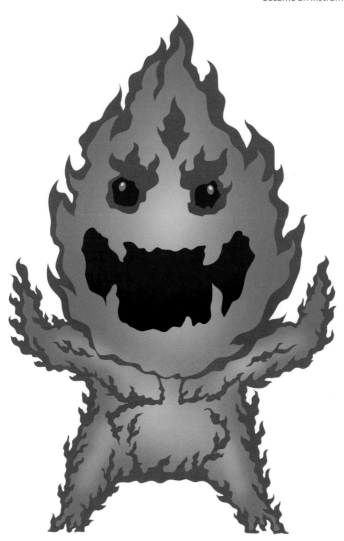

WEDO
& NEUROWEDO
INTELLECTUAL EVOLUTION

Instruments of Evil
Plant origin
Some Wedo evolve to Neurowedo
Overdeveloped intelligence

Practice: Creating the character
Development of antagonistic pairs

1. Outline and Sketching

The heads are two ellipses, one short for the stooped Wedo and another longer for the straight-backed Neurowedo. In the sketching stage, add definition to the robes and the individual facial features.

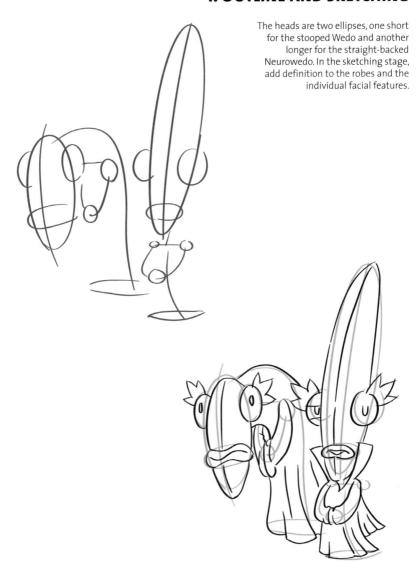

2. INKING

For the faces of the characters, make minimal use of lines. For the folds in the robes, used curved lines to give a sense of movement preventing the figures from appearing static.

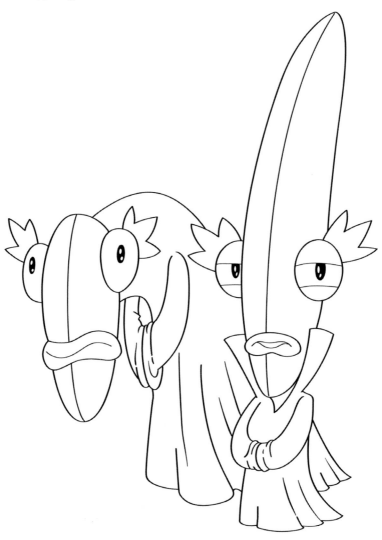

3. COLOUR

Cool colours represent the evil
nature of these characters, which
is highlighted with the use of
two colours on each chibi's face.
The colours of the mouths and
eyelashes add contrast and a sense
of happiness to the characters.

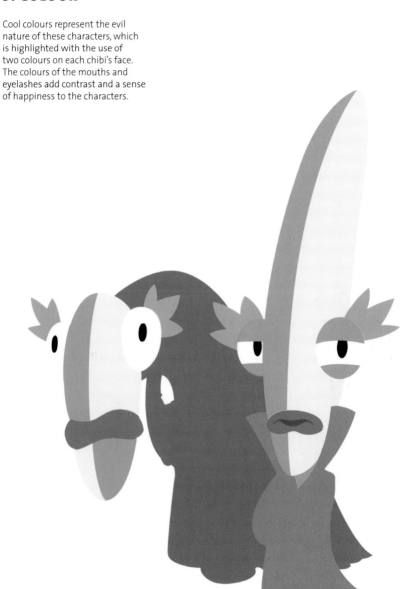

4. Lighting and Shading

Use lighting to draw attention to the faces and especially to the eyes of Neurowedo. Powerful layers of shading give volume to the image.

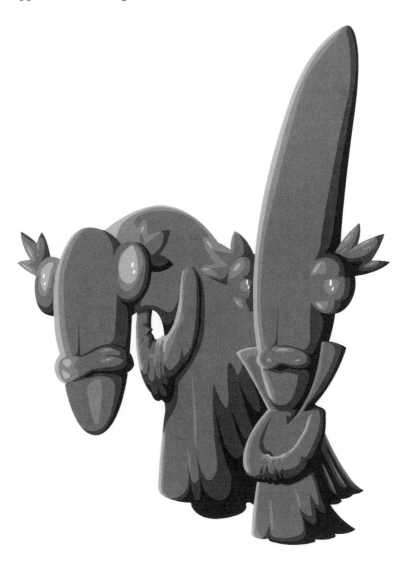

5. Finishing Touches

The proud look in Neurowedo's eyes, showing his intelligence, contrasts with Wedo's lost look and empty expression. Opposites always work together.

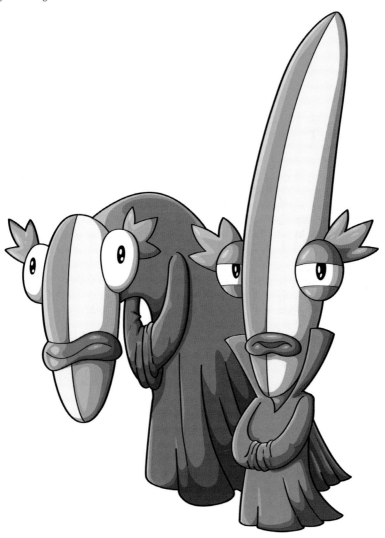

ENVIRONMENT, ANGLES AND PERSPECTIVE

While this book focuses on how to create and represent chibis, we will dedicate part of this chapter to the environments where these characters live. To do this we must become familiar with the concepts of angle and perspective.

The angle at which we decide to draw characters or backgrounds determines how the viewer will perceive the chibis and their world. For example, if we draw a figure viewed from above, it will seem smaller than it really is, whereas if we draw it viewed from below it will appear larger. The environment is important to help us understand the correct dimensions of our character. To draw a character and its environment realistically we must apply the rules of perspective. This will allow us to achieve more credible and professional illustrations. It is not as complicated as it appears, so let's get practising to achieve some amazing results.

BROZZER
LOCATION AND ENVIRONMENT

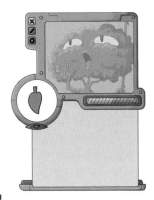

Defender of Good
Plant origin
Lord of the plants

Practice: Creating the character
Define the situation
and environment

1. OUTLINE AND SKETCHING

Using a big head and a small body as a starting point, use a tree to create a character whose roots are feet, the branches are arms and the crown is the head.

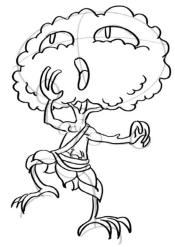

2. Inking

A smooth application of ink blends
the character with the surroundings.
Standing on a large rock, he holds
on to a vine and lets out a cry that is
heard throughout the jungle.

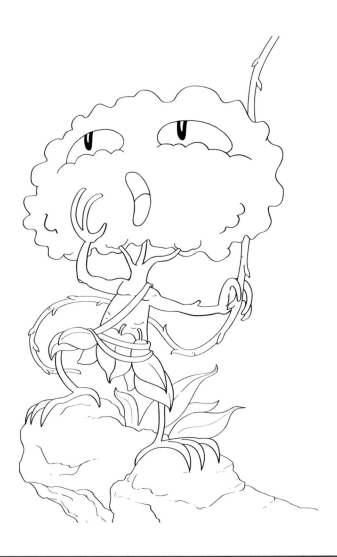

3. Colour

Use typical plant-life colouring such as browns and greens. The different shades of green on the leaves give life to the illustration without being too far-fetched.

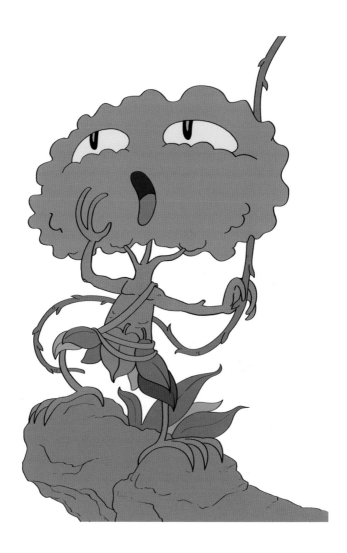

4. Lighting and Shading

Use two layers of lighting and two layers of shading. In this way, it is easier to represent the volume and movement of the leaves and the angles that define the rock.

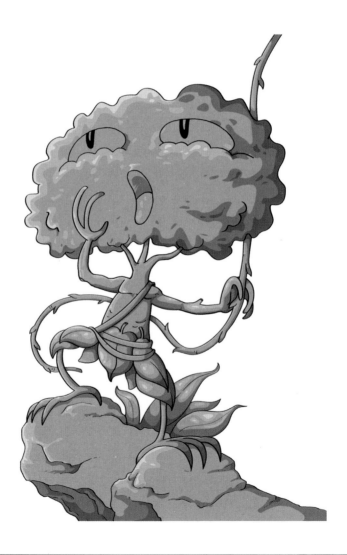

5. Finished Character

We have managed to maintain the basic structure of a tree with Brozzer without this preventing us from creating an active and agile character. His pose and attitude make it evident that he is in his natural habitat.

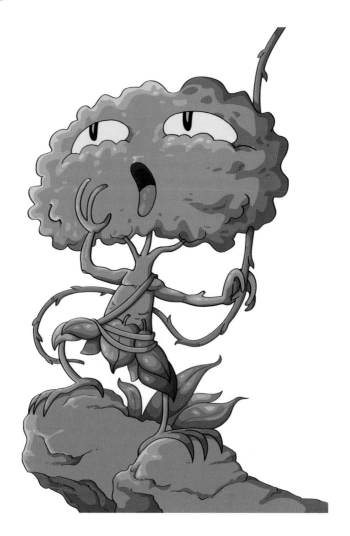

6. INKING IN BACKGROUND

Use straight and angular lines for
the mountains and curved and
rough lines for the trees. The further
away the object you want to draw,
the finer are the lines.

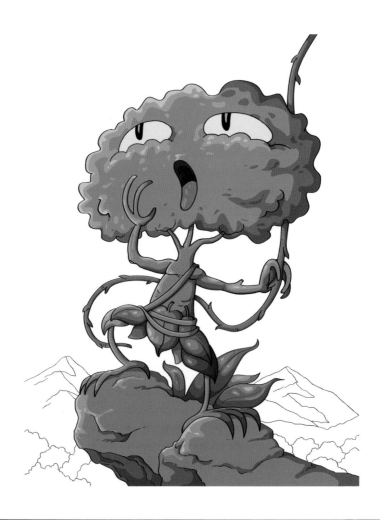

7. Finishing Touches

The colour, lighting and shading complete the environment. With a few details, you have managed to place Brozzer in the wide-open wilderness.

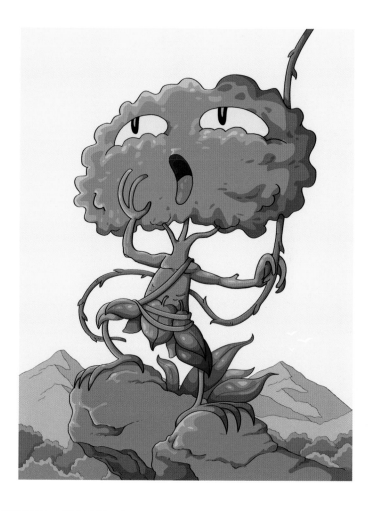

STACK
PERSPECTIVE

Defender of Good
Animal origin
Hyperagility

Practice: Creating the character
Introduction to perspective

1. OUTLINE AND SKETCHING

With a simple outline, you can position the head and the tail. In the sketching stage, add volume to achieve the body, tail and arms. The wild hairstyle and the acorn belt stand out.

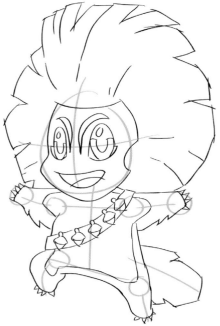

2. Inking and Colour

Use shades of violet and purple. Violet is often used to represent magical beings. Purple shows the restless nature of the character.

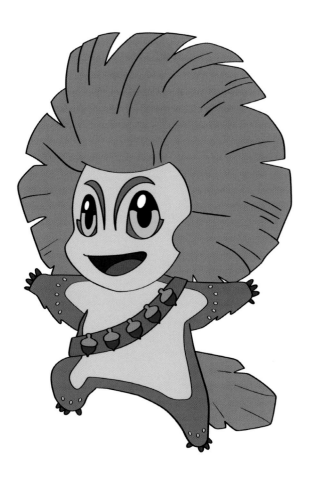

3. Finished Character

To add the finishing touches to the
character you need to apply layers
of lighting and shading. Emphasise
the chibi's hair using strong lighting
and two layers of shading in the hair
and tail.

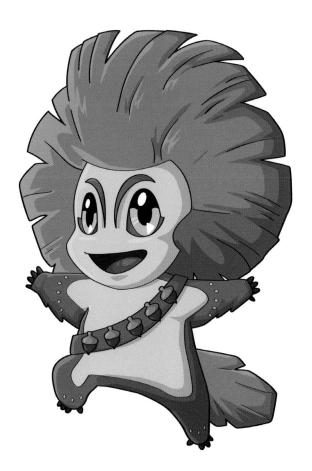

4. PERSPECTIVE 1

Draw just one side of the items
to which you want to apply the
perspective. Draw them in the
correct positions so that they can be
integrated into the picture.

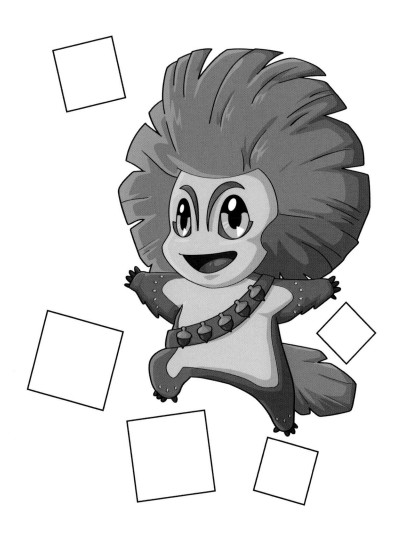

5. PERSPECTIVE 2

Choose a vanishing point (in red) and draw straight lines to it from each vertex or corner of each item.

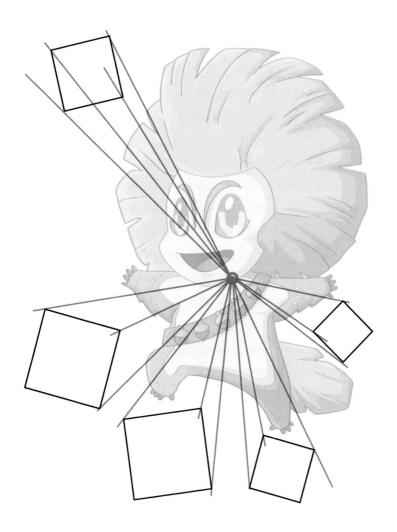

6. Perspective 3

Reproduce each element a little further back, making sure that the vertices or corners coincide with the drawn lines.

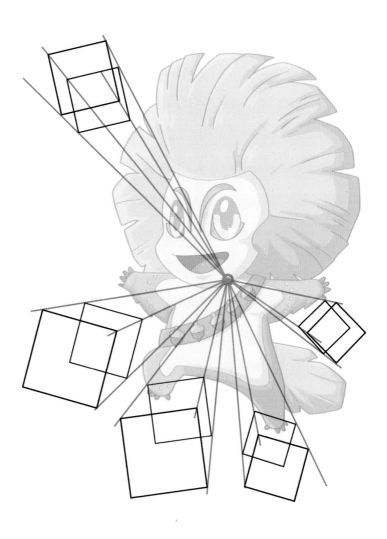

7. Finishing Touches

You have all the lines you need. Follow them to achieve a perfect perspective.

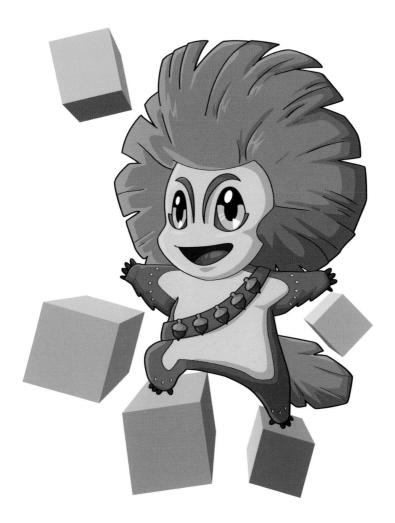

BIGEY
High Angle Shot

Defender of Good
Animal origin
Does not evolve
The largest chibi in Chiwelland

Practice: Creating the character Use
of the high angle shot
Size references

1. Outline and Sketching

A large ball represents the head and above this you can place the other elements. In the sketching stage, draw hands, feet, fur and fangs and even Bigey's large eyelid.

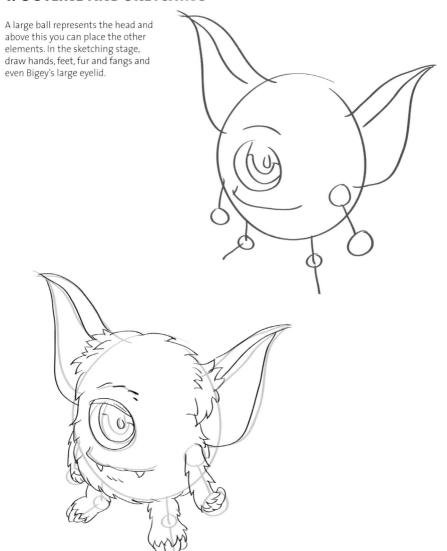

2. INKING

Use uniform, wavy and jagged lines
to represent the hair. Only use finer
lines to represent interior details.

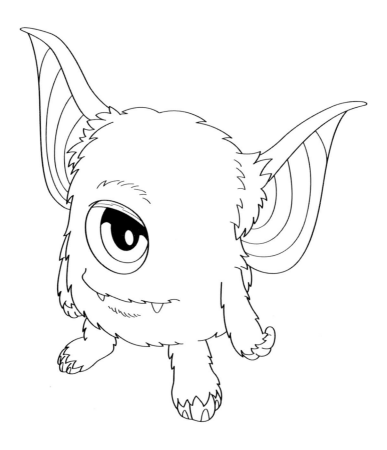

3. COLOUR

For Bigey's fur I have chosen an off-white tone, and have differentiated furless parts with shades of blue. In contrast to this range of cool colours, I have used a red tone in the eye.

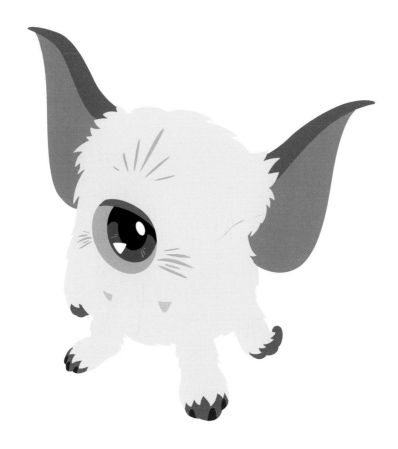

4. LIGHTING AND SHADING

As this character is very hairy, you should use jagged lines of lighting and shading to portray the thickness and weight of the coat. The lines used for the ears are more stylised.

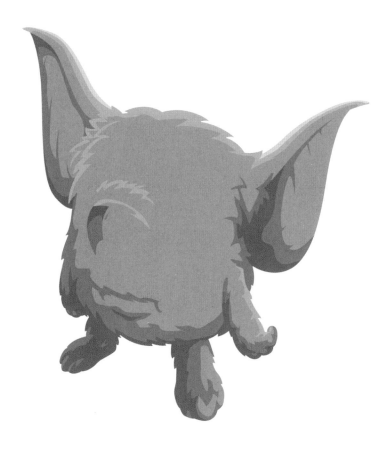

5. INKING IN BACKGROUND

Keep the lines of the environment
simple and angular, with few
details. That way you give the
impression that the environment is
far away in the distance.

6. Colour

Apply green and brown – nature's colours. The green of the tree tops should stand out from that of the grass. In the next step, finish the background by adding simple shading and lighting.

7. Finishing Touches

By adding tiny trees, you can show just how big Bigey is. By drawing a tree in his hand, you force Bigey to interact with the environment, and you start to tell a story.

VIROS
LOW ANGLE SHOT

Instrument of Evil
Techno-organic origin
Does not evolve
Destroys any technological tool and
uses it to build replicas of himself

Practice: Creating the character
Low angle shot

1. Low Angle

A high angle shot (view from above, panel 1) dwarfs a character. A low angle shot (view from below, panel 2) enlarges him or her. This applies even to Viros, which measure less than two centimetres (one inch) tall.

2. Low Angle Shot Outline

Because Viros is a very geometric
creature, use panel 2 as a reference
for the perspective. Inside, draw the
outline of Viros in a low angle shot.

3.Sketch of Low Angle Shot

With the panel as a reference it is
very easy to make a detailed outline
of the character. From this point
of view you can already see the
impressive appearance of Viros.

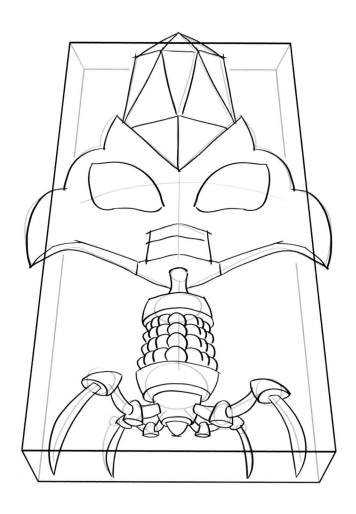

4. Inking

Make careful use of symmetry
and plenty of straight lines,
typical of a metallic creature.
The inking will therefore have a
strong geometric aspect.

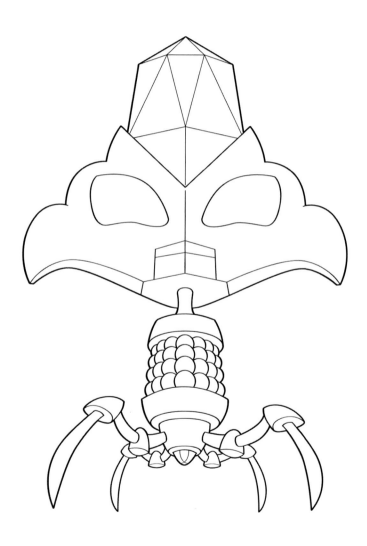

5. Colour

The yellowish and greenish tones mixed with metallic blues warn us that we may be dealing with a dangerous and even poisonous enemy.

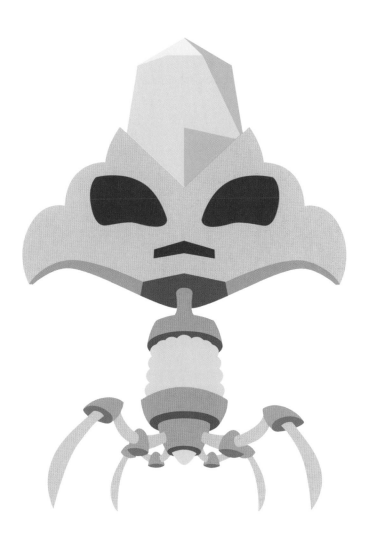

6. Lighting and Shading

The large number of flat sides along with many curved elements allow you to play with lighting and shading, which are reflected in fun shapes and patterns.

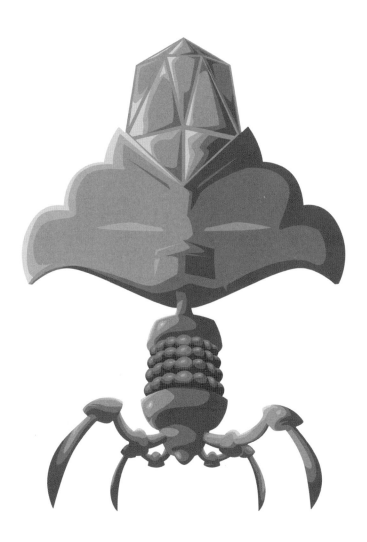

7. FINISHING TOUCHES

This low angle shot makes Viros look enormous. The details in the eyes emphasise the inhumane nature of this tiny miracle of technology ready to wreak havoc.

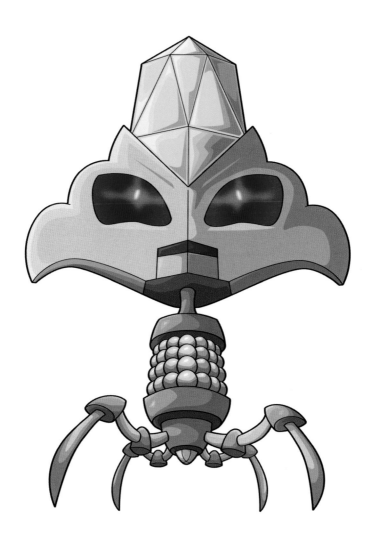

CUTEBOT
ROTATIONS & ANIMATION

Defender of Good
Robotic origin
Does not evolve
Very strong, intelligent and tireless

Practice: Character creation
Rotations
Animation

1. OUTLINE AND SKETCHING

His outline is typical of a humanoid chibi: large head and small body. A large hemisphere of glass protects his electronic brain. The shape of the face and hips gives identity to the character.

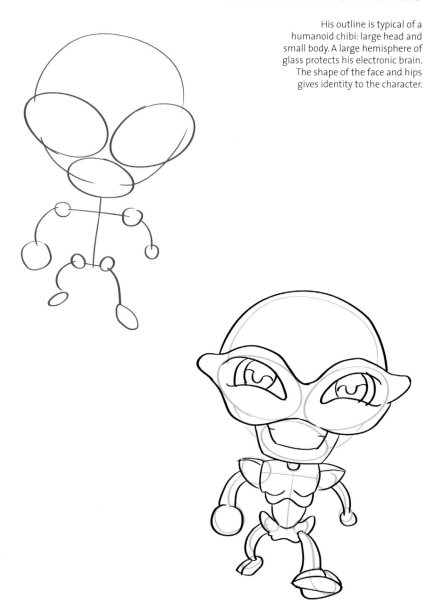

2. INKING

The lines are fine and rounded,
typical of a polished metal robot.
The lines on the arms, stomach and
legs immediately make it obvious
that it is a robot.

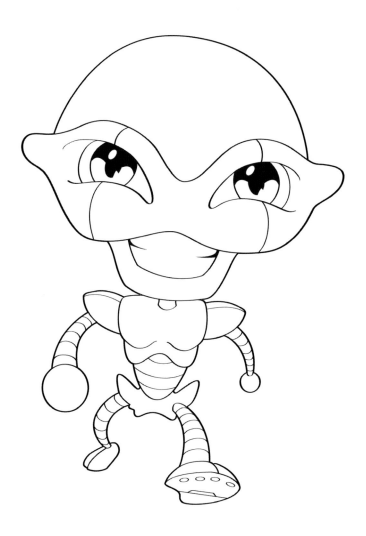

3. Colour

Cutebot likes to be the centre of attention, so I opted for yellow to stand out. The blue tones refer to his metallic nature.

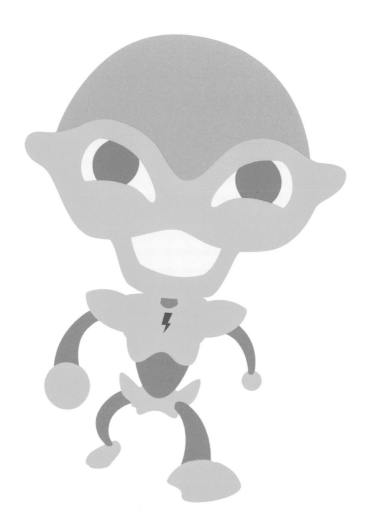

4. Lighting and Shading

Many of the elongated and rounded lights and shadows do not touch the edges of the figure. This is a simple way to represent the metallic sheen.

5. Finishing Touches

Cutebot is a happy robot ready to perform any task no matter how hard or boring it is. Once he has decided on a mission, no one can change his itinerary.

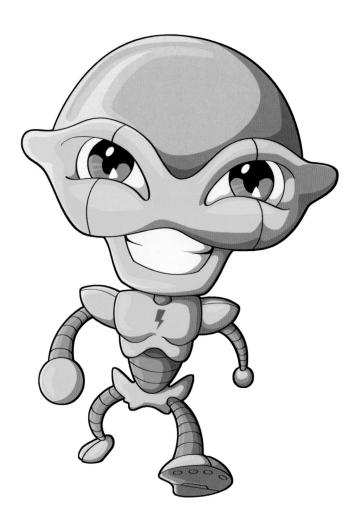

6. ROTATIONS: FRONT VIEW

To draw any character well, you must
know how they look from all angles.
The front view is crucial because it
shows the face, body or clothing of
the character.

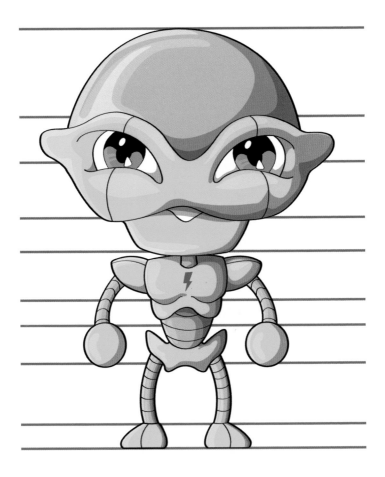

7. ROTATIONS: REAR VIEW

Many characters carry things on their backs that are not visible from a front view. Cutebot is equipped with two reactors that enable him to fly.

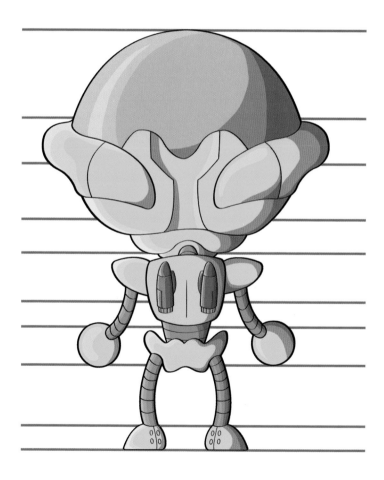

8. Rotations: Side View

This view helps us understand the anatomy of the character. The posture, the shape of the head or whether the character is carrying a few extra kilos, can all be seen best from this view.

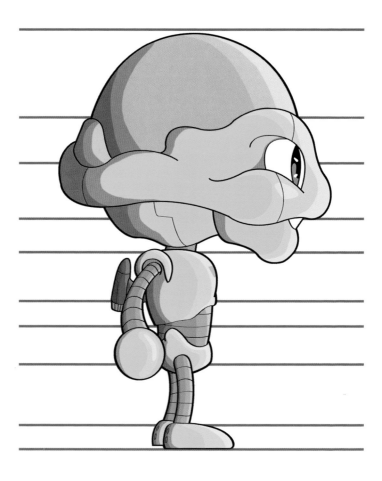

9. ANIMATION

With both traditional methods and with the current advanced computer techniques, it is very easy to make simple, effective animations such as the ability to walk or fly.

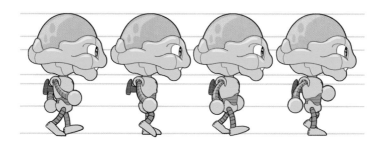

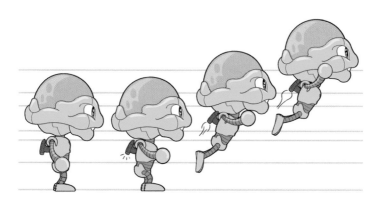

GUMORE
Facial Expressions

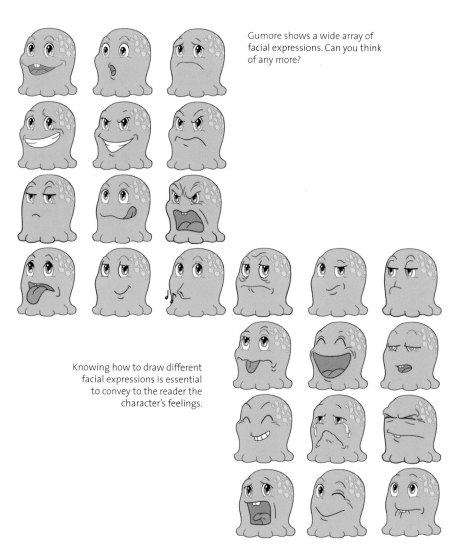

Gumore shows a wide array of facial expressions. Can you think of any more?

Knowing how to draw different facial expressions is essential to convey to the reader the character's feelings.

Acknowledgements

Thank you Raquel, Fil, José, Isabel
and Darko for your contribution to
this work.